IMAGES
of America

ALTON

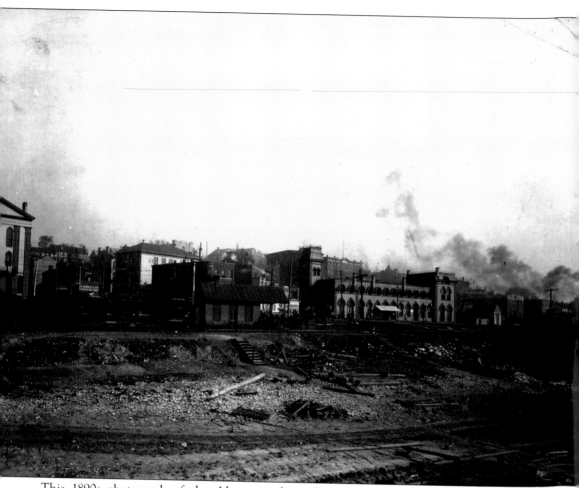

This 1890s photograph of the Alton riverfront shows city hall at the far left and the locomotive-shaped Alton Union Station toward the right. Public buildings and church spires rise up the hill. Note the steps leading down to the riverfront, the cordwood, and the wagon at the bottom right. (Courtesy of Donald J. Huber.)

On the cover: Taken in May 1910 by photographer Lewis Wickes Hine (1874–1940), these young male workers are on their noon lunch break at the Illinois Glass Company. Hine documented numerous groups of workers with photographs and notes as part of an investigation on behalf of the National Child Labor Committee. Although their work was undoubtedly hard, their boyish grins and impish poses are charming. (Courtesy of Library of Congress.)

IMAGES
of America

ALTON

Cheryl Eichar Jett

ARCADIA
PUBLISHING

Published by Arcadia Publishing
Charleston, South Carolina

Printed in the United States of America

Library of Congress Catalog Card Number: 2008938586

For all general information contact Arcadia Publishing at:
Telephone 843-853-2070
Fax 843-853-0044
E-mail sales@arcadiapublishing.com
For customer service and orders:
Toll-Free 1-888-313-2665

Visit us on the Internet at www.arcadiapublishing.com

*To my mother Charlotte, my role model and constant source
of loving support, and for my father Gene, who always
wrote and always made music.*

CONTENTS

ACKNOWLEDGMENTS

I owe grateful thanks to the following individuals who have been particularly generous, supportive, and enthusiastic in helping with this book: Donald J. Huber; Suzanne Halbrook and Brett Stawar at Alton Regional Convention and Visitors Bureau; Mary Westerhold and all the staff at Madison County Historical Society; Alan and Suzi Journey; Gene Kunz; Jim and Sandy Belote; Jim Shrader and Dan Brannen at the *Telegraph*; John J. Dunphy at Second Reading Books; Mark Bohart; Keith Wedoe; Jamison O'Guinn; Sharyn and George Luedke; William R. Iseminger; and last, but definitely not least, my loving family who read and reread—Charlotte Eichar, Thomas Jett III, Erica Jett, Nicole Jett, Ethan Firestone, and James Lask.

Thanks are also due to the historians, journalists, and keepers of history who have paved the way for this book and others to come, including Jim Shrader and Dan Brannen at the *Telegraph*; Charlene Gill and Charlene Johnson at Alton Museum of History and Art; the staff at Hayner Public Library; Charlotte Stetson; Harold Meisenheimer; Robert Graul; and many others.

I also wish to thank my editor at Arcadia Publishing, Jeff Ruetsche, for his guidance, patience, support, and enthusiasm during each step of the process. Although many persons have contributed to the success of this book, any and all errors or omissions are solely mine.

INTRODUCTION

Alton—nestled into the limestone bluffs, named for a land speculator's son, and blessed with plentiful natural resources—has a rich and diverse story interwoven with the history of the state of Illinois and the United States of America. Near the confluence of three great rivers, close to halfway down the 2,300-mile length of the Mississippi, and at the southwestern edge of Illinois, the 21st state, Alton was perfectly situated to grow into a major river city.

From its beginnings in 1818 as a site for a ferry service between Illinois and St. Louis through its strength as an industrial city in the late 19th and early 20th centuries, the river and the railroad shaped Alton's history and defined its culture. Both river and rail brought a variety of people into the community and easily transported products out. However, the river proved to be foe as well as friend during several disastrous floods.

Rufus Easton, territorial delegate and postmaster in St. Louis, saw the river bend area as the perfect spot for a ferry service and named the new town Alton after one of his sons. Although Easton is popularly given much credit for establishing the city of Alton and is perhaps the best known of Alton's founding fathers, other farseeing individuals played important roles in the early years of the city. Joseph Meacham platted Upper Alton, which remained a separate town until it was annexed to Alton in 1911. Maj. Charles Hunter bought land east of Henry Street in Alton and established Alton on the River, later known as Hunterstown.

Each community had its own distinct flavor. Alton became a bustling commercial and port area near the river, and the area north, headed up the bluffs, became the Middletown district, where the wealthier citizens built their homes. Hunterstown became industrial and a home neighborhood to many workers. The community of Godfrey was established by Capt. Benjamin Godfrey. In Upper Alton, early institutions of education were established—the Wyman Institute (later Western Military Academy) and Shurtleff College. Near Upper Alton was a community called Salu with a pottery and brick works. Milton was a settlement on Wood River Creek at a place called Wallace's Mill, where both a sawmill and a gristmill were powered by the creek.

Through the steamboat years of the 1820s and 1830s, Alton became an ambitious, bustling, and profitable river town due to its site near the confluence of three great rivers—the Mississippi, the Missouri, and the Illinois—and its proximity to St. Louis. Alton ranked among other early river towns such as Peoria and Quincy as one of the top pork-packing centers in the Midwest and jockeyed among other prominent towns such as Jacksonville and Peoria for the honor of becoming the new Illinois state capital. Instead of the site of the capital, Alton became the home of the first state penitentiary. Completed in 1831, the prison welcomed its first "guests" in 1833.

Alton's prosperity took a turn for the worse with the nation-wide financial panic of 1837, the murder of abolitionist Elijah Lovejoy in November 1837, and the failure of several major companies. However, by the 1850s, Alton was enjoying "railroad fever" and had the good fortune to be the first link to the Mississippi River from Chicago via railroad. Abraham Lincoln was a strong proponent of railroads, having experienced as a circuit judge the inconveniences of frontier travel. He endorsed the Alton and Chicago Railroad as being "a link in a great chain of railroad communication which shall unite Boston and New York with the Mississippi."

The Civil War played a major part in Alton's history. The murder of abolitionist newspaper publisher Elijah Lovejoy in 1837 could rightly be called the first incident of the Civil War. Abraham Lincoln and the "little giant" Stephen A. Douglas came to Alton in 1858 for their seventh and final debate in front of the newly built city hall; 6,000 people attended. The Alton Penitentiary became a Confederate prison with deplorable conditions; over 1,300 prisoners died within its stone block walls due to smallpox and other diseases and are buried in the Confederate cemetery on Rozier Street.

Just after the Civil War began in 1861, Capt. James H. Stokes captured the St. Louis Arsenal in a brilliant and daring exploit to retrieve arms for Illinois troops. With the assistance and cooperation of his force and many loyal Alton citizens, 10,000 muskets plus other arms were transported from St. Louis to Alton aboard the steamer *City of Alton* and loaded onto Chicago and Alton Railroad freight cars bound for Springfield. Alton was also an important stop on the Underground Railroad, and about a half dozen buildings are believed to have been used as such.

With river and railroad, water, and grain fields nearby, Alton became a natural location for breweries, bakeries, and numerous other businesses. By the end of the 19th century, Alton boasted over 100 industries, several institutions of higher education, and plenty of magnificent Queen Anne, Victorian, and Italianate architecture. The late 1800s were the golden years of industry, banking, building, and architecture. The industrial character of the town and the fortunes being made sorted the city into markedly different social classes and neighborhoods. "Millionaire's Row" along Twelfth Street included the mansions of John Drummond (tobacco) and Edmond Beall (manufacturing), homes designed by Lucas Pfeiffenberger. The workers' neighborhoods evolved simultaneously in the lower areas of town.

In Alton, the second Industrial Revolution and the Gilded Age extended into the 20th century. In 1912, the newly formed Alton Board of Trade published *Reid's Brochure of Alton*, extolling the virtues of Alton, including the natural resources; the transportation options; the educational facilities; the banking and financial establishments; and the beautiful homes, churches, and public buildings for those that would move, establish businesses, and become a part of the fabric of Alton's everyday life. Throughout the 20th century, Alton saw changes and experienced highs and lows reflective of the larger national picture.

Through Alton have passed the famous, including Fr. Jacques Marquette and Louis Joliet, Meriwether Lewis and William Clark, Elijah Lovejoy, Abraham Lincoln, Stephen A. Douglas, Lyman Trumbull, Nancy Reagan, Adlai Stevenson, Miles Davis, and the infamous, including James Earl Ray and the killers of Elijah Lovejoy. The river and the railroad brought diverse individuals, including entrepreneurs, land speculators, skilled craftsmen, religious and educational leaders, river men, railroad builders, Civil War prisoners, soldiers, doctors, photographers, architects, and dreamers. To tell the story of Alton is to tell the story of the people that came, built, lived, worked, and died here.

One

THE BEGINNINGS

The first inhabitants in the region were the people of the great Mississippian Indian culture centered at Cahokia Mounds, but by approximately 1500 A.D., this culture had disappeared. By the time of the first French explorers in the area, the Illinois Confederacy of tribes was established. On their trip southward on the Mississippi River in 1673, Louis Joliet and Fr. Jacques Marquette and the others traveling with them were the first white men known to see the future site of Alton.

In 1783, Jean Baptiste Cardinal from Cahokia established a settlement called Piasa at or near present-day Alton. After Cardinal was taken prisoner by Native Americans, his family returned to Cahokia. Solomon Pruitt arrived in the area in 1806 and found a stone house was in use at that time by some French as a trading post with the Native Americans. Pruitt later reported that he found Eli Langford had established a ferry close to the Wood River.

Before 1817, Rufus Easton of St. Louis envisioned the area as perfect for land development and a ferry service. He acquired land and platted the town of Alton, naming it for one of his sons. Around 1817, Joseph Meacham laid out the town of Upper Alton on higher ground. Both Easton and Meacham encountered legal difficulties in their land speculation, partly due to the national bank failure of 1819 and land sales not being as brisk as anticipated. Years of litigation followed.

Several Native American attacks were recorded during the early settlement years. During the War of 1812, Capt. Thomas E. Craig burned a Native American village in northern Illinois, capturing 77 French, French–Native American, Native American, and American individuals and, as historian James E. Davis stated, "shunted this assortment of humanity down the Illinois River, abandoning them on a dreary November day south of modern Alton." Illinois governor Ninian Edwards, embarrassed by the debacle, compensated those stranded in the Alton area.

By 1836, Alton was thriving. Its location, plentiful natural resources, steamboat traffic, burgeoning industries, influx of entrepreneurs and workers, and location of the first state penitentiary made it one of Illinois' most prominent cities of the time.

The great Mississippian Indian culture centered at Cahokia Mounds had virtually disappeared by about 1500 A.D. By the time of the first French explorers in the area, the Illinois Confederacy of tribes had established villages throughout the American Bottom and along the Illinois River. (Painting by William R. Iseminger, courtesy of Cahokia Mounds State Historic Site.)

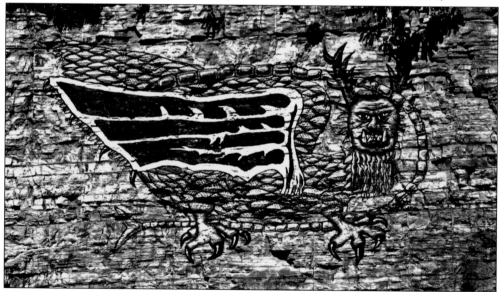

The Piasa Bird pictographs on the bluffs near present-day Alton were first seen by non-indigenous people in 1673, when Fr. Jacques Marquette and Louis Joliet traveled south on the Mississippi River. Scholars disagree on the origin and significance of the pictographs, although the word *piasa* is popularly claimed to be an Illini word meaning "the bird that devours men." A recreation of the image on the bluffs was completed in 1998. (Courtesy of Alton Regional Convention and Visitors Bureau.)

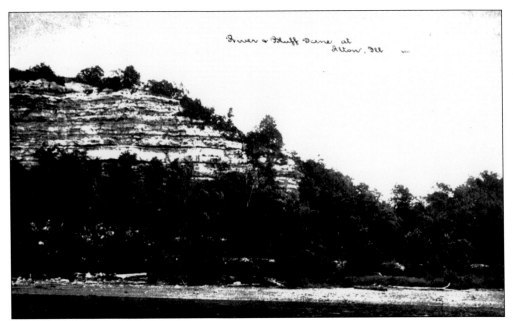

The limestone bluffs along the Mississippi River just above modern Alton rise some 250 feet above the river level. This is the view that Marquette and Joliet saw as they approached the site of the future city of Alton. The plentiful limestone would eventually be used as building materials and in the manufacture of lime. The rich layer of clay would be utilized for the production of bricks and pottery. Quarrying became a major industry and attracted stoneworkers and masons to the area. Henry Watson owned a quarry at Ninth and Market Streets, which provided stone for the Alton Water Works, the St. Louis Union Station, and many homes and other buildings. Watson also contracted business with the railroads. (Courtesy of Madison County Historical Society.)

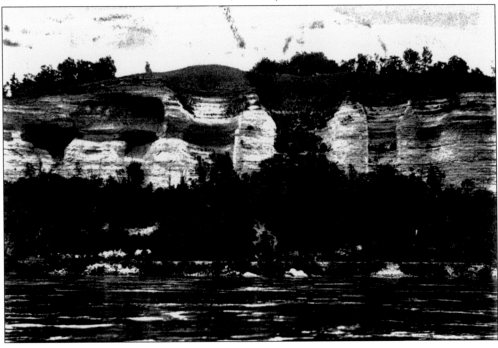

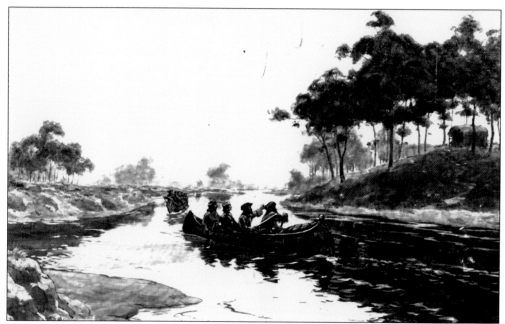

French explorers Louis Joliet and Fr. Jacques Marquette traveled down the Mississippi River in 1673 in the first French expedition to find the Pacific Ocean. Past the confluence of the Mississippi and Ohio Rivers, their provisions ran low. Worries about unfriendly Native Americans and doubts that their route would take them to the Orient hastened their decision to end the expedition. They turned around to begin their return journey upriver. (Courtesy of Library of Congress.)

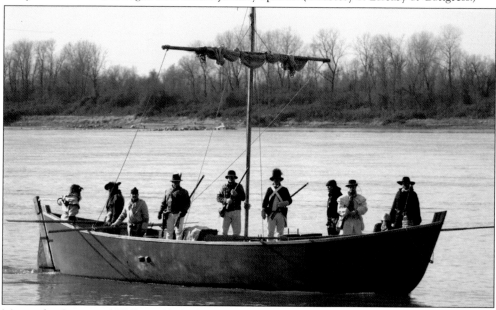

Meriwether Lewis and William Clark chose to winter in 1803–1804 at a 400-acre site at the mouth of the Wood River ("Dubois"), owned by fur trader Nicholas Jarrot of Cahokia, near present-day Alton. Here the troops would train, plan, gather supplies, and prepare for their long journey in hopes of discovering the Northwest Passage. This site was their point of departure on May 14, 1804. (Photograph by Gene Kunz, courtesy of Alton Regional Convention and Visitors Bureau.)

In 1814, a group of women and children of the Moore and Reagan families were headed out to pick green beans when they were attacked by Native Americans. One woman and six children were killed in what became known as the Wood River Massacre. The original marker, hand-carved by a grieving father for his children, was found in a backyard in Riverton, Illinois, in 1980 and returned to the Alton area. (Courtesy of Alton Regional Convention and Visitors Bureau.)

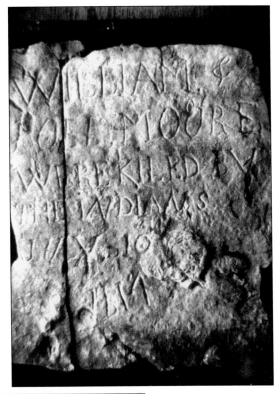

The seven victims of the Wood River Massacre were buried in the Vaughn Cemetery. In the cemetery are also buried a Revolutionary War veteran, a state senator and War of 1812 veteran, and several Civil War veterans. The Vaughn Cemetery is located on Route 111, just south of the airport in nearby Bethalto. An early log church was built on this site in 1809. (Photograph by Cheryl Eichar Jett.)

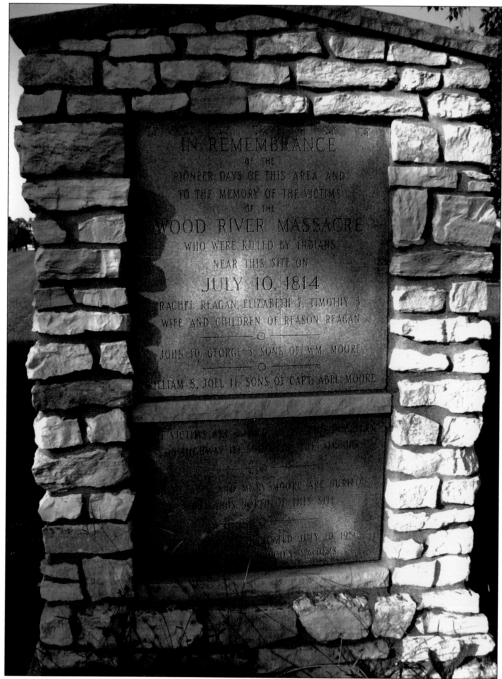

A monument to honor the Wood River Massacre victims was located in 1910 about 300 yards from where the massacre occurred, now the Alton Mental Health Center grounds. In 1980, a new monument was erected farther east on Route 140 in Gordon Moore Park and dedicated by 200 descendants of Capt. Abel Moore and the Bates family. (Photograph by Cheryl Eichar Jett.)

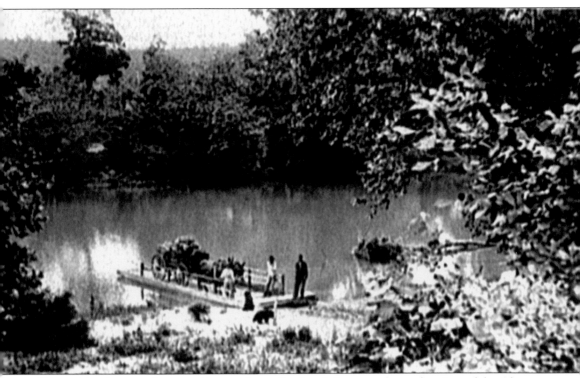

Competition between ferry services was keen. Smeltzer's Ferry was located upriver of the Alton site. Joseph Meacham and Samuel Gilham began a ferry, later known as Fountain Ferry, in 1817 out of Piasa Creek. And Rufus Easton began his ferry service between Alton and Missouri in 1818. This image of a ferryboat may have resembled one of the Alton area ferries. (Courtesy of Library of Congress.)

Capt. Benjamin Godfrey arrived in Alton in 1832 and purchased this home. Godfrey and Winthrop Gilman established Godfrey, Gilman and Company, a shipping company for agricultural goods, fur, and livestock that at one point was the largest business in Illinois. They built a stone four-story warehouse on William Street to accommodate their stock of goods. In 1838, Godfrey founded Monticello Female Seminary and later led the community in financing and building the Alton and Chicago Railroad. Godfrey was an outstanding businessman and financier, and Alton benefited for many years from his leadership abilities and later his philanthropy. (Above, photograph by Joseph T. Golabowski, courtesy of Library of Congress; below, courtesy of Madison County Historical Society.)

The Black Hawk War may not have figured prominently in Alton's history; however, two companies were enrolled in Alton under Capt. Josiah Little and Capt. David Smith. Solomon Pruitt, an early settler, had been the first captain of one of those companies but was promoted to lieutenant colonel. The great Sauk leader Black Hawk, who played an important part in Illinois history, wrote his autobiography after the war ended. (Lithograph by Lehman and Duval, courtesy of Library of Congress.)

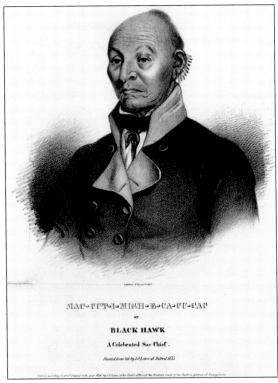

This house on Liberty Street was built in 1837 on a four-acre tract by Cyrus Edwards, brother of Gov. Ninian Edwards. Nathaniel Buckmaster, who had commanded a battalion of companies from Madison and St. Clair Counties in the Black Hawk War, bought the house for $5,000 in 1852; he died three years later. Pictured here are his daughter Virginia, her husband Joseph Quigley, and their son (on pony) Nathaniel Buckmaster Quigley. (Courtesy of Madison County Historical Society.)

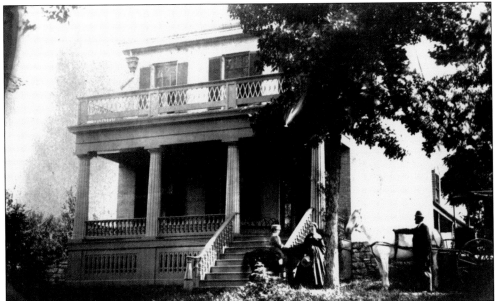

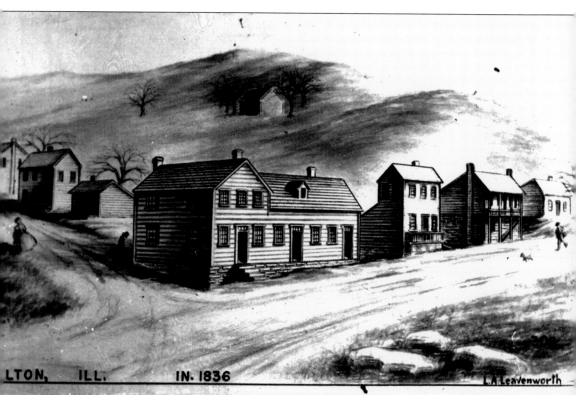

LTON, ILL. IN. 1836 L.A. Leavenworth

LYCEUM HALL BUILDING, CORNER BROADWAY AND ALBY,
WHERE THE ALTON TELEGRAPH PUBLISHED ITS FIRST ISSUE, JANUARY 15. 1836.

The Lyceum Hall Building on the corner of Broadway and Alby (named for Rufus Easton's daughter) Streets was the site of publication of the first issue of the *Alton Telegraph* on January 15, 1836. By then Alton had its first mayor, John M. Krum, who later served as a St. Louis mayor, and Illinois had authorized Alton to build the first state penitentiary. Alton was incorporated as a city the following year. (Courtesy of the Telegraph.)

Two

THE RIVER

As the river had been critical to Native American settlement and travel, it was also instrumental in attracting Alton's first white settlers and crucial as its first mode of long-distance travel. Alton is located at the confluence of three great rivers. It became an important port city because of its position on the Mississippi River, with the mouth of the Missouri River 7 miles below and the mouth of the Illinois River 18 miles above.

Native Americans plied the waters in their canoes for centuries before the European whites came. French traders and missionaries came south on the Mississippi River via the Sac and Fox Rivers from Quebec. Meriwether Lewis, William Clark, and the Corps of Discovery embarked from this area on their great journey up the Missouri River.

The river highways carried people and cargo south with ease, but the return trip north against the current was painfully slow and difficult. Keelboats could be taken back up the river, but it was a slow process. Flatboats, the "boats that never came back," were dismantled in New Orleans, and their wood put to other uses. The explosion in use of steamboats after 1820 revolutionized travel and expedited the movement in both directions. Soon after Rufus Easton and Joseph Meacham platted Alton and Upper Alton, the favorable location and the relative ease of travel via steamboat began to bring entrepreneurs, dreamers, and workers into the area, men who would become leaders and developers in their new community.

Alton grew rapidly and enjoyed prosperity from steamboat trade through the 1830s. Travel was now quicker and easier for both passengers and cargo, with numerous steamboats up and down the Mississippi River. It was said that one could go down to the riverfront in any river town at any time of day and see a steamboat going either upstream or downstream. Coal in the Alton area provided fuel for the steam boilers on the boats. The downsides to steamboat travel included the many snags and boiler explosions, which sank their fair share of boats, and steamboat racing, which often gave passengers more of a ride than they bargained for.

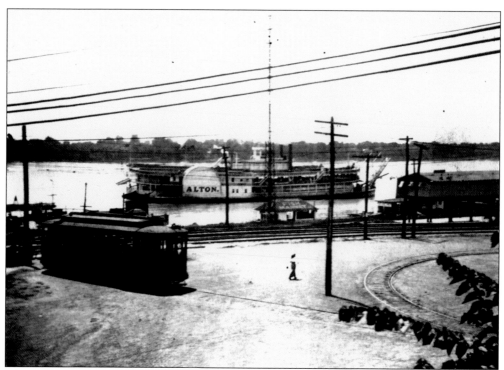

The Eagle Packet Company owned and operated the steamers *Alton, Cape Girardeau, Bald Eagle, Spread Eagle, Grey Eagle,* and *Eagle,* plus the Alton wharf boat. Another steamboat, the *DeSmet,* named for a Jesuit missionary, was acquired from a competitor, Capt. Joseph LaBarge. The company was founded in Warsaw, Illinois. In 1900, it was moved to St. Louis and remained in operation until 1946. (Courtesy of Madison County Historical Society.)

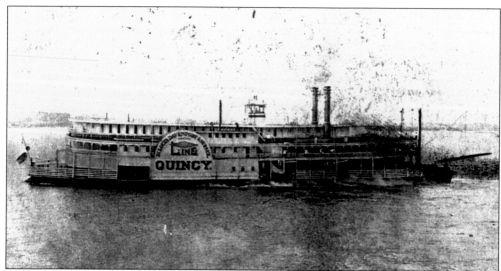

The steamer *Quincy* of the Streckfus Steamboat Company connected Alton and St. Louis with cities north all the way to St. Paul, Minnesota. The Streckfus Steamboat Line also operated the steamers *St. Paul, Dubuque,* and *Sidney.* Another company, the St. Louis and Hamburg Packet Company, operated the steamers *G. W. Hill* and the *Omaha.* (Courtesy of Cheryl Eichar Jett.)

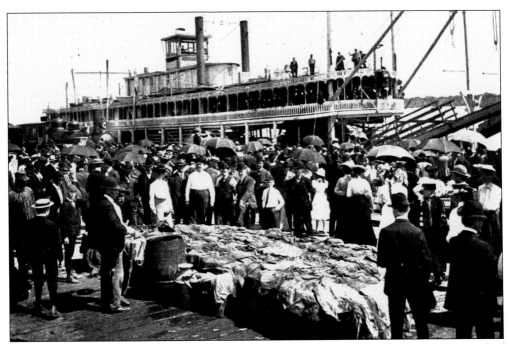

The major flood in 1903 caused not only flood damage but repercussions in the travel of passengers and the moving of freight. Additional boats aided passenger travel while railroad lines were underwater. Here the steamer *Spread Eagle* unloads a huge crowd of passengers at the Alton Union Station. (Courtesy of the Telegraph's Bob Graul Collection.)

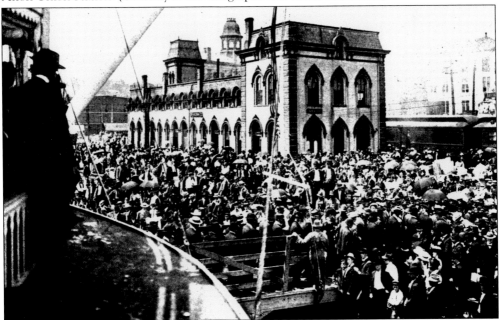

Passengers and cargo are backed up at the riverfront in another scene during the 1903 flood. Note the unique locomotive shape of the station. Major floods occurred in Alton in 1844 (the first one recorded), 1858, 1903, 1927, 1937, 1943, 1965, 1973, 1982, 1983, 1993, and 2008. (Courtesy of the Telegraph's Bob Graul Collection.)

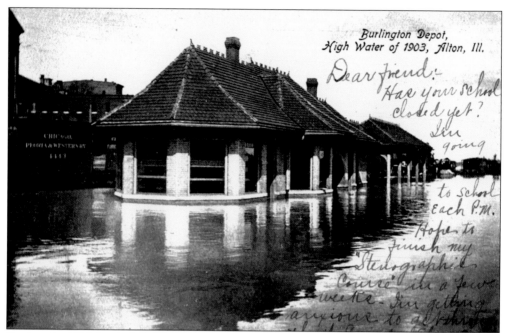

Burlington Depot,
High Water of 1903, Alton, Ill.

Dear friend:-
Has your school
closed yet?
I'm going
to school
each P.M.
Hope to
finish my
"Stenographic
Course" in a few
weeks. I'm getting
anxious to get through

During the 1903 flood, the Chicago, Peoria and St. Louis Interurban Depot was partially under water. Passengers were served from this line that was headed along the bluffs to Clifton Terrace, Lock Haven, Elsah, Chautauqua, or Grafton or making inland trips to Jerseyville, Springfield, or Peoria. (Courtesy of Madison County Historical Society.)

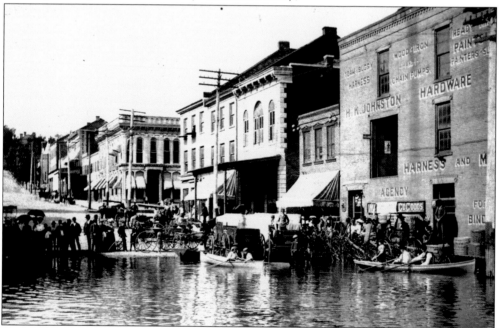

At the corner of Second and State Streets, the H. K. Johnston Hardware Company (right) at 144 to 150 Second Street was a popular place for crowds to gather and observe floodwaters. For many years, the water height was recorded on the corner of the large store. The building is no longer standing. (Courtesy of Donald J. Huber.)

22

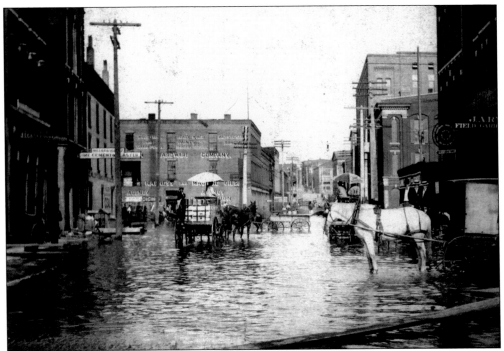

Another shot of the H. K. Johnston Hardware Store (center) from a different angle shows the 1903 floodwater down Second Street. At Alton, the flood crested that year on June 9. Second Street was the home of many of Alton's retail businesses and stores, including the Alton Feed Company, Foreman Brothers Gents' Furnishings, Joseph Krug Florist, Walter B. Schmoeller Tailor, and F. H. Keller Electric Shoe Repairing Shop. (Courtesy of Donald J. Huber.)

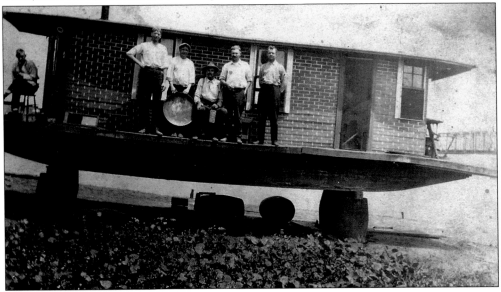

A house up on moorings such as this one was not an uncommon sight in the low-lying area of Alton or along the riverbanks on the east side of town. People who lived in these areas expected their neighborhoods to flood occasionally. Seated at center is James R. Harris, who worked at Alton Electric (later Union Electric) for 45 years. (Courtesy of Suzi Journey.)

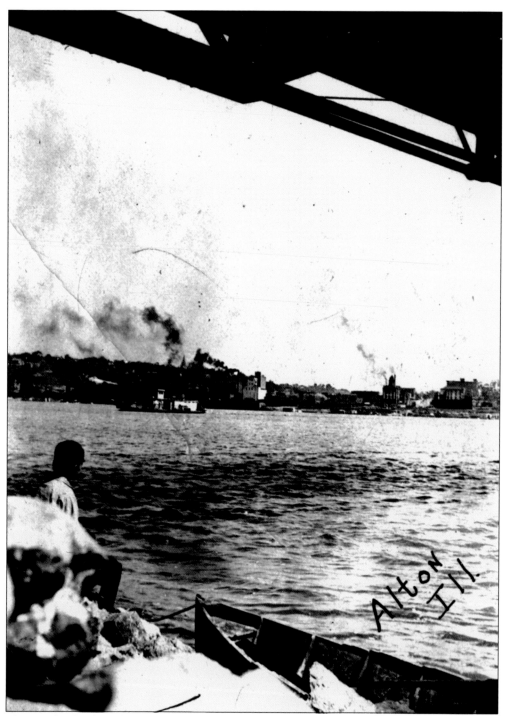

The 1912 book *Alton Illinois Illustrated* stated, "The freight tonnage to and from Alton for the year 1910 approximately was 2,783,132 tons." It further stated that there were 7,075 miles of navigable streams (including the Mississippi, Missouri, Ohio, Illinois, Tennessee, and Cumberland Rivers) available at the time for Alton watercraft. (Courtesy of Madison County Historical Society.)

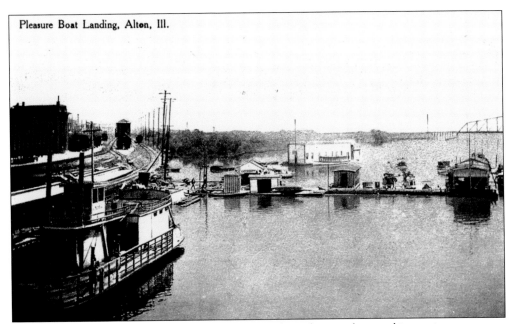

Pleasure Boat Landing, Alton, Ill.

After the rise of the railroads in the late 1800s, steamboats became less vital in moving passengers and freight. However, the popularity of the boats remained for leisure travel and recreation, and many surviving steamers became strictly excursion boats. Due to snags and boiler explosions, more than half the steamboats on the Mississippi River sank. (Courtesy of Cheryl Eichar Jett.)

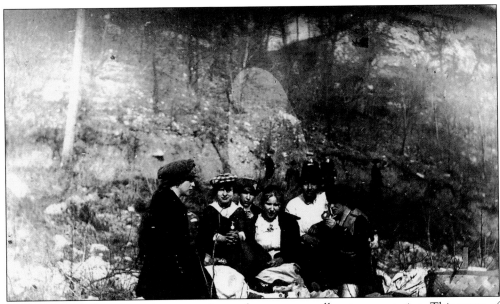

The Mississippi River served as recreation and scenery as well as transportation. This group of ladies, all members and friends of the Harris and Waters families, enjoys a picnic along the bluffs overlooking the river. The area north of Alton along the river was and still is popular for eagle and other bird watching, picnicking, hiking, or just river watching. (Courtesy of Suzi Journey.)

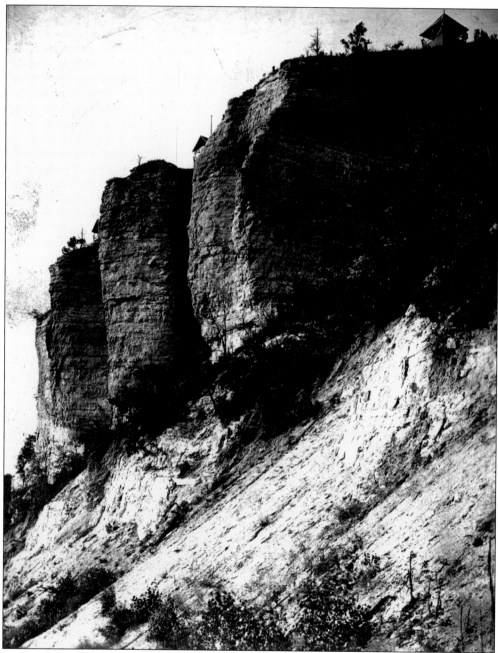

The section of the bluffs along the Mississippi River north of Alton known as the palisades was captured in an early-1900s photograph taken by W. D. Armstrong, an Alton musician and historian. He served as president of the Madison County Historical Society from its organization in 1921 until his death in 1936. (Courtesy of Madison County Historical Society.)

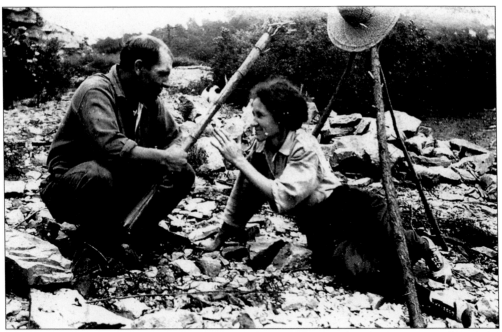

James B. Harris, an Alton Gas and Electric Light Company worker for 42 years, and Dorothy (Dolly) Jones were married in 1919 after he served in Germany during World War I. James B. Harris was known as "Jim B." to distinguish him from his father, James R. Harris. Both Jim B. and Dolly were Alton natives and lived their entire lives in the Alton area. In these photographs, they enjoy a day together along the bluffs overlooking the Mississippi River. In the photograph above, note the straw hat hanging on the stick tripod and Dolly's shoes. (Courtesy of Suzi Journey.)

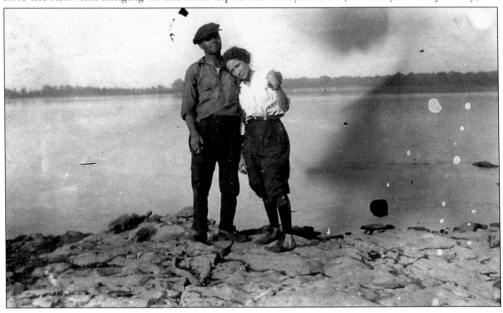

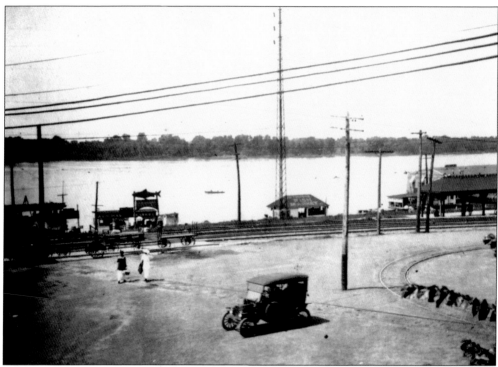

The proximity of the railroad lines and the city itself to the riverfront created a bustling and vital center of transportation along the riverfront. In the early 1900s, automobiles appeared on the scene and added to the mix of trains and trolleys. The "modern" trolley replaced the mule- and horse-drawn streetcar that had served the citizens of Alton from 1867 until about 1892. Trolleys provided city service and the two interurban lines offered fares to neighboring communities and St. Louis. (Courtesy of Madison County Historical Society.)

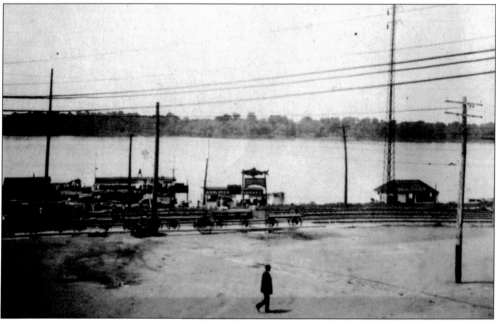

From the 1840s until the 1860s, loaded keelboats were tied to the sides of steamboats to serve as barges. Later in the century, grain and other cargo were transported mainly on the railroads. Steamboats were altered to make them capable of pushing multiple large barges carrying heavy loads such as gravel and sand. In the 1900s, diesel engines replaced steam. (Courtesy of Suzi Journey.)

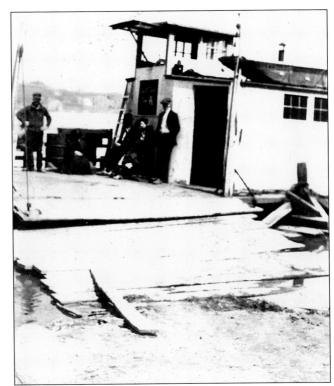

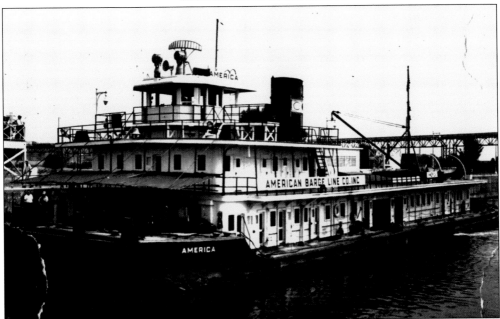

This towboat is one belonging to the American Barge Lines of Louisville, Kentucky. Blaske Barge Lines of Alton became a subsidiary of the company in the mid-1900s. Since the late 1800s, the Blaske family had included deck hands, river pilots, captains, boat builders, and towboat operators. Members of the family now own Blaske Marine on the Missouri River. (Courtesy of the Telegraph.)

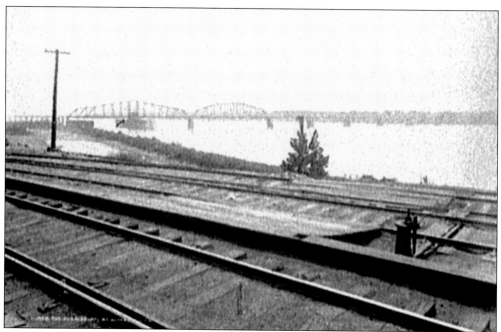

This misty-looking view of the Mississippi River was taken around 1900 and shows the railroad bridge that was constructed in 1894 in the background and the railroad tracks along the river in the foreground. One could leave from Alton for St. Louis on the hour during the day, and in 1912, a round-trip fare cost 90¢ or $10 for a monthly ticket of 60 rides. This figured out to 16.66¢ one way. (Courtesy of Library of Congress.)

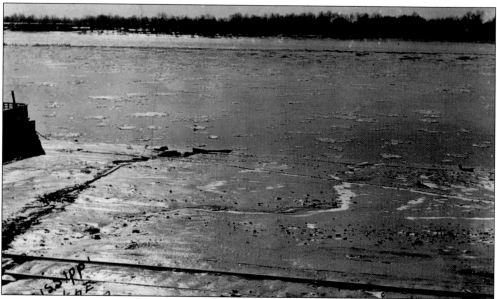

This c. 1910 photograph shows the Mississippi River in winter. Wintertime activities on the river included ice fishing and ice cutting. The riverfront was often dotted with fishermen's shacks during the cold months. From November to March, ice jams could occur, slowing or stopping navigation and damaging moorings, watercraft, and levees. Most ice jams occurred in December and January. (Courtesy of Madison County Historical Society.)

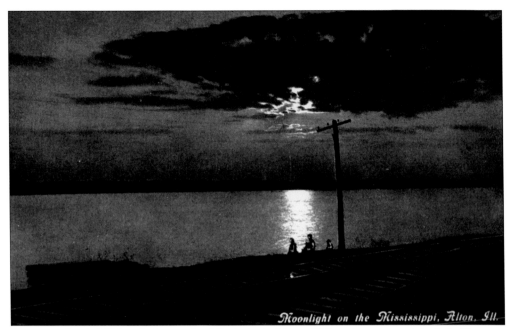

A postcard titled "Moonlight on the Mississippi, Alton, Ill." evokes a nostalgic feel. One can imagine the steamboats plying the black waters up and down the river at night. In *Life on the Mississippi*, Mark Twain wrote, "When I was a boy, there was but one permanent ambition among my comrades in our village on the west bank of the Mississippi . . . the ambition to be a steamboat man always remained." (Courtesy of Madison County Historical Society.)

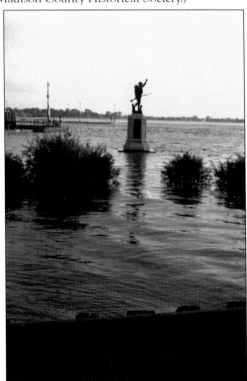

The floodwaters of 1943 gave the appearance of marooning the World War I monument located near the riverfront. Later the monument was moved to the Veterans of Foreign Wars property on higher ground. The worst flood in the area's history was the great flood of 1993. (Courtesy of Madison County Historical Society.)

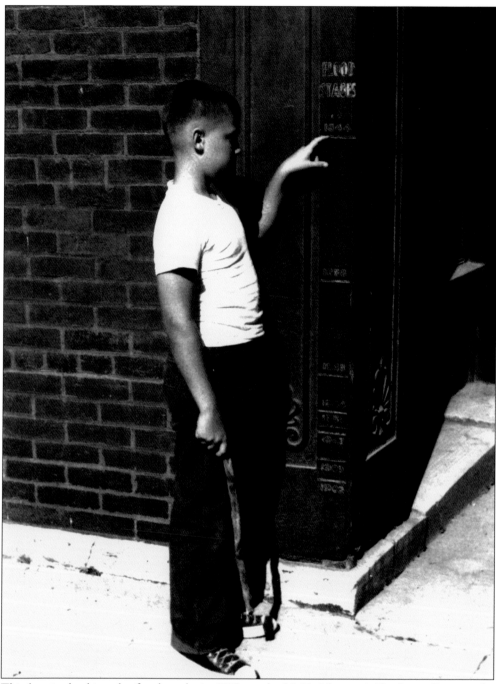

This boy is checking the flood marks in 1943 on the H. K. Johnston's Hardware Store at the corner of State and Broadway Streets. The 1943 flood mark is well below those of the 1844 and 1858 marks, which were notated on the ornate corner post. Flood measurements were recorded there until the building was demolished in the mid-1900s. (Courtesy of Madison County Historical Society.)

Three

THE RAILROAD

Just as the river was Alton's first mode of transportation, playing a vital part in the city's growth, the railroad was the second and equally important factor in Alton's growth as a major Illinois city. Although ultimately the railroad was a huge success for Alton, it was a struggle to begin the process. In 1836, the Illinois state legislature appropriated funds for construction of railroads in Illinois, but the nationwide financial panic of 1837 ended those efforts. A charter for the Alton and Sangamon Railroad for a line to be built between Alton and Springfield was issued by the state in 1841.

The two Alton citizens who were primarily responsible for the railroad being built in Alton were sea captains and entrepreneurs Capt. Benjamin Godfrey and Simeon Ryder, who both came to the area from Cape Cod. Although 400 tons of iron for the railroad arrived in Alton by steamboat from New Orleans in 1841, delays in raising capital halted the project again. Eventually Godfrey and Ryder raised funds by local subscription and from investors in the East. Godfrey engaged Irish immigrants as laborers, supervised track construction, lived in a railroad car to be near the work, and mortgaged his own home to ensure the completion of the plan.

Abraham Lincoln was a strong proponent of railroads; in a letter to the *Illinois Journal*, he endorsed the Alton and Sangamon Railroad as "a link in a great chain of railroad communication which shall unite Boston and New York with the Mississippi."

During the mid-1800s, Alton was the southernmost point among all the rail connections between Chicago and St. Louis. Proponents in Alton of an Alton railroad bridge could not sufficiently interest investors to build one. The Chicago and Alton Railroad was the first line from Chicago to reach the Mississippi, causing many to think that Alton would become the rail hub of Illinois. It did not, but it did become an important link later on in the mighty Illinois Central Railroad. The completion of the Eads Bridge in 1867 ensured that St. Louis would top Alton as a transportation hub.

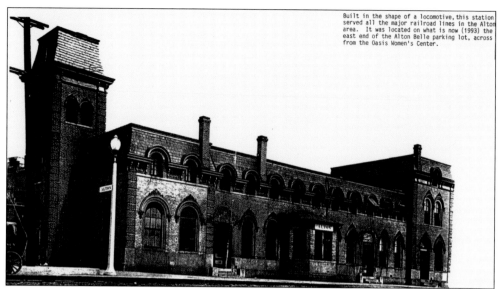

The locomotive-shaped Alton Union Station was built in 1866 by the Chicago and Alton Railroad and the Cleveland, Cincinnati, Chicago and St. Louis Railway (Big Four) and served all the major railroad lines in the area. It contained a ticket room, a baggage station, and a hotel. As many as 65 trains per day came and went during its peak years. Unfortunately, the building was razed in 1956; it was located on part of what is now the Argosy Casino parking lot. (Courtesy of Madison County Historical Society.)

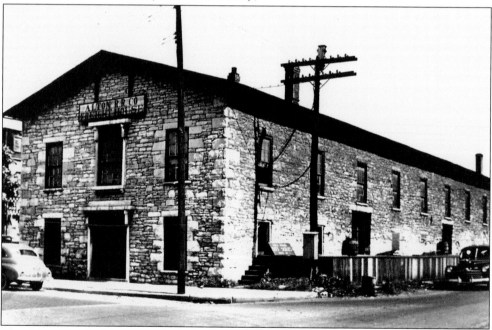

The Alton Freight House was built by Capt. Benjamin Godfrey out of native limestone and opened in 1852. Later it was used by the Gulf, Mobile and Ohio Railroad. Freight shipments through Alton were claimed to be lower in price and better expedited due to its geographical location. By 1900, shipments from Alton were known to be delivered in New York City in less than four days. (Courtesy of Donald J. Huber.)

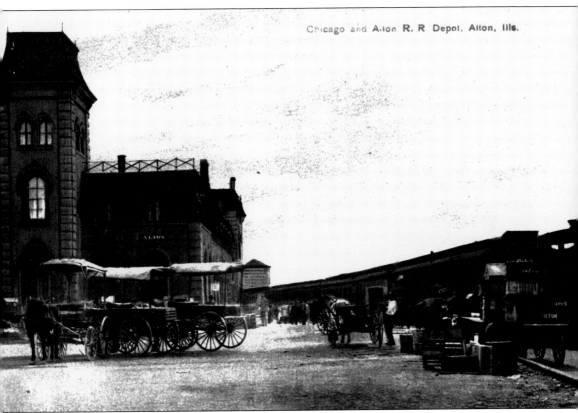

Chicago and Alton R. R. Depot, Alton, Ills.

In the 1860s and 1870s, several prominent visitors came through the Alton Union Station. A group of Civil War heroes traveled throughout Illinois, stopping in Alton. Pres. Andrew Johnson and also William H. Seward each spoke to the assembled crowd, but it was reported that Gen. Ulysses S. Grant, although he did not speak, received the most applause. Another president, Millard Fillmore, visited Alton in 1852. (Courtesy of Madison County Historical Society.)

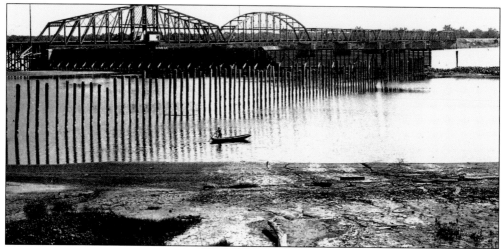

The railroad bridge across the Mississippi, which opened in 1894, linked seven different railroads in Illinois and Missouri or, as some said, linked the Atlantic Ocean with the Pacific Ocean. Opening events for the Tuesday, May 1, event included a parade, a banquet, and a reception; thousands of invitations to the festivities were mailed. The bridge was built of steel with a double set of tracks, fixed spans, and a pivot span, which was a section that could swing to one side to allow large boats and barges to pass. In 1912, the Missouri and Illinois Bridge and Belt Railroad Company was offering service back and forth from one state to the other. (Above, courtesy of Donald J. Huber; below, photograph by Clayton B. Fraser, courtesy of Library of Congress.)

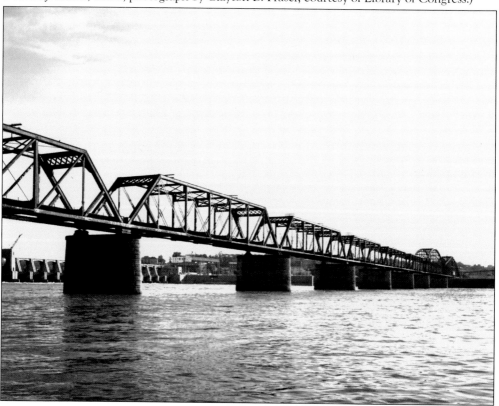

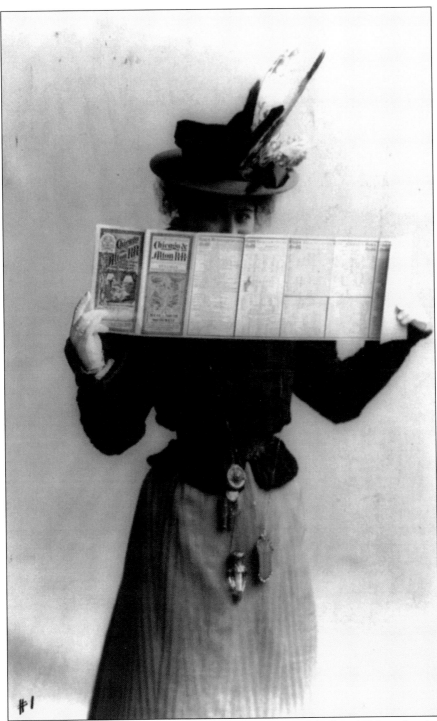

Edna Wallace Hopper, a popular stage and silent film actress of the late 1800s and early 1900s, peeks over the top of a Chicago and Alton Railroad schedule. She lent her name to various products, including railroads, toothpaste, and a line of cosmetics; in her later years, her face-lift procedure was filmed as a documentary. (Courtesy of Library of Congress.)

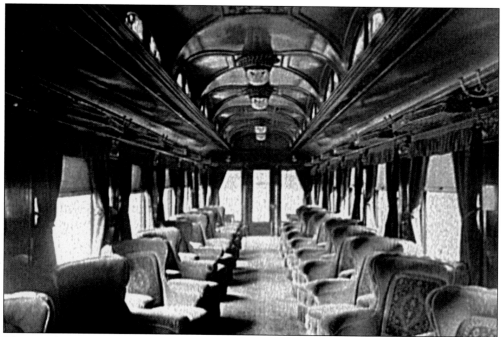

This is what the interior of a Chicago and Alton Railroad car looked like around 1900. Sometime after 1900, libraries were added to some cars. The Chicago and Alton Railroad carried Pres. Abraham Lincoln's body home to Springfield; a scale model of that train is on display at the Museum of Funeral Customs in Springfield. (Courtesy of Library of Congress.)

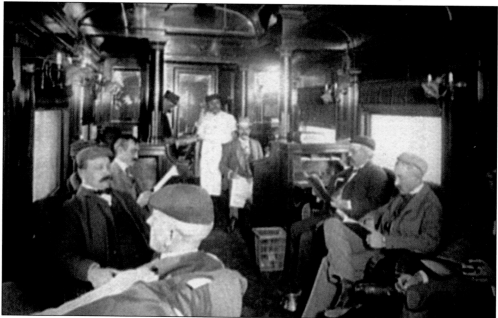

A Chicago and Alton Railroad car interior is filled with passengers in this c. 1900 photograph. The railroad was in operation from 1847 (as the Alton and Sangamon Railroad, later as the Chicago and Alton Railroad, and finally as the Alton Railroad) until 1947 when it merged with the Gulf, Mobile and Ohio Railroad. (Courtesy of Library of Congress.)

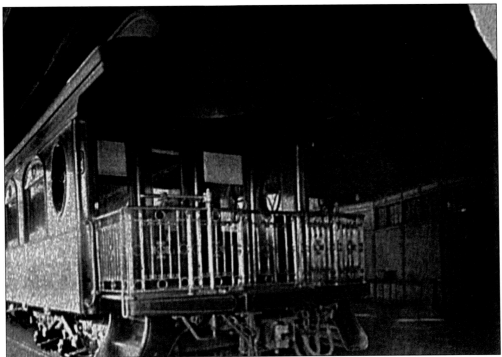

This c. 1900 photograph of a Chicago and Alton Railroad train car's rear platform was produced by Detroit Publishing Company, which printed tens of thousands of postcards on different subjects, including transportation. A rear platform such as this one was generally part of a parlor car and was good for sightseeing, marriage ceremonies, or, when the train was stopped, for giving speeches. (Courtesy of Library of Congress.)

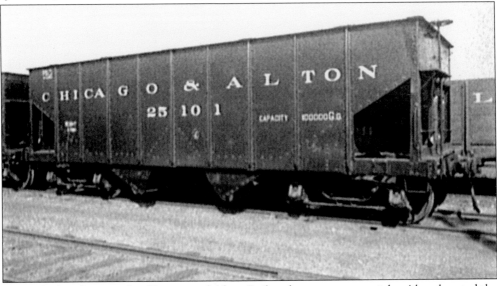

A standard coal car on the Chicago and Alton Railroad was a common sight. Alton boasted the lowest prices for coal of anywhere in Illinois or Missouri, due to the bituminous coal field near Alton. In 1912, the price ranged from 25¢ to 32¢ per ton. McCarthy Coal and Ice Company on Henry Street advertised "Coal that is all coal." (Courtesy of Library of Congress.)

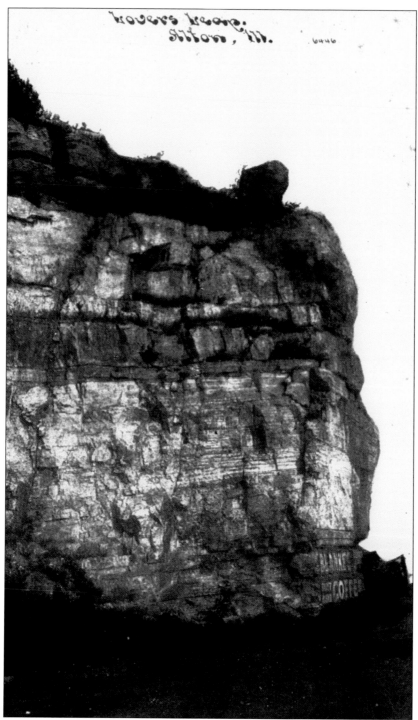

In 1912, Alton boasted "seven steam railroads, also two interurban electric roads, and complete city service" in the *1912 Alton Illinois Illustrated*. By then, a railroad bridge over the Mississippi connected Alton with St. Louis and St. Charles, Missouri. (Courtesy of Madison County Historical Society.)

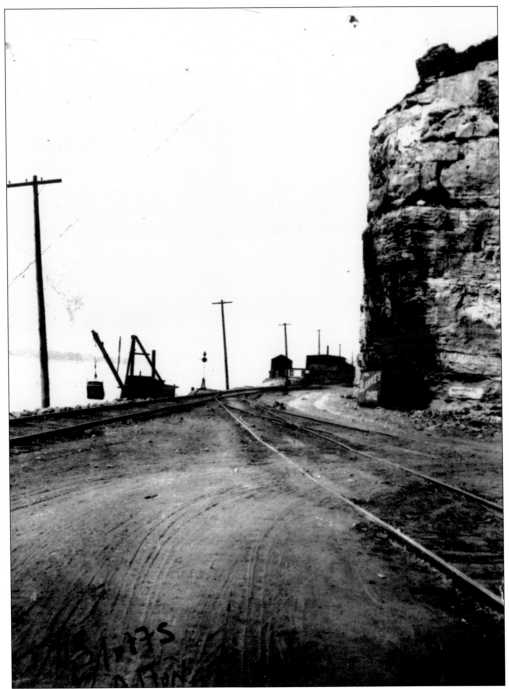

The Bluff Line Railroad running out of Alton along the river and bluff line linked passengers with Clifton Terrace, Chautauqua, Elsah, and Grafton. Resort hotels such as Clifton Terrace popped up along the bluff line. The Clifton Terrace Hotel could accommodate 100 guests and offered boating, fishing, billiards, and a bowling alley. (Courtesy of Madison County Historical Society.)

The *Alton Limited* passenger train featured a library car. The Chicago and Alton Railroad ran close to a dozen trains daily. The *Alton Limited* was considered the premier train of the railroad line and left Chicago daily at 11:00 a.m., arriving in St. Louis in time for supper. Library cars

disappeared from the passenger trains around the 1920s, possibly due to the availability of cheaper reading material. (Courtesy of Library of Congress.)

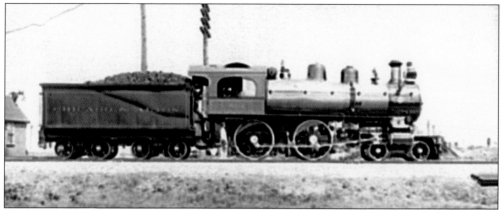

The Chicago and Alton Railroad locomotives were built by various manufacturers, including the American Locomotive Company's Brooks Works. The last five steam locomotives built for the line were delivered in 1921. After the Alton route merged with the Gulf, Mobile and Ohio Railroad in 1947, the steam locomotives were retired. (Courtesy of Library of Congress.)

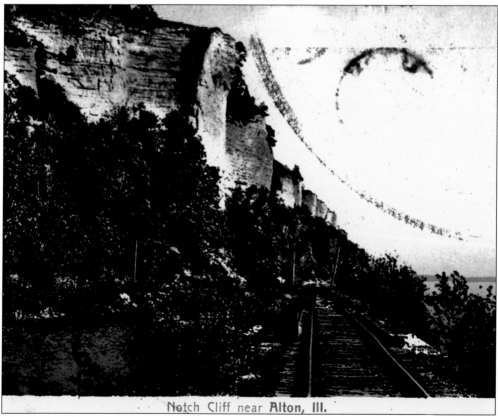

Notch Cliff near Alton, Ill.

This postcard published by the St. Louis News Company shows the Grafton Line at Notch Cliff above Alton, looking south. Passengers took advantage of a variety of rail options to travel locally and beyond. (Courtesy of Madison County Historical Society.)

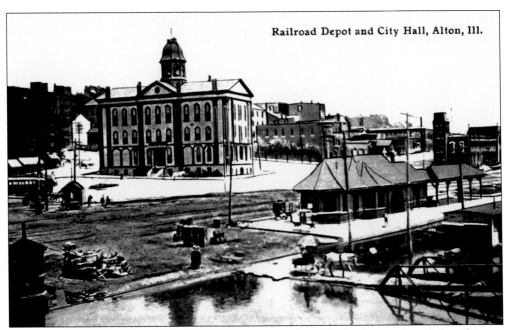

Railroad Depot and City Hall, Alton, Ill.

The imposing city hall, the Alton Union Station in the right background, and the Chicago, Peoria and St. Louis Interurban Depot were all adjacent to the riverfront. Passengers and freight could be transferred between rail travel and river travel with ease. (Courtesy of Madison County Historical Society.)

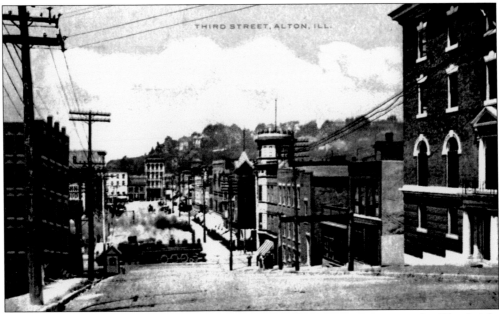

THIRD STREET, ALTON, ILL.

Locomotives pulling freight cars through downtown Alton was a common sight. The freight trains serviced the manufacturing area to the east of downtown. Traffic jams were said to be common, due to the mix of trains, interurban lines, trolleys, and eventually automobiles. This train is crossing Third Street. (Courtesy of Madison County Historical Society.)

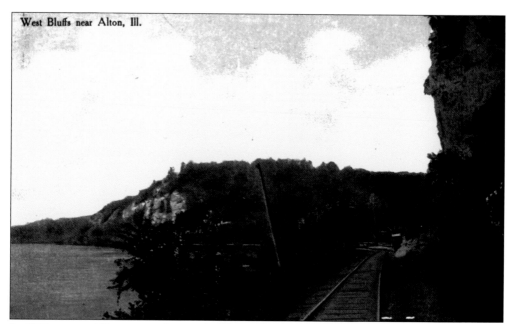

West Bluffs near Alton, Ill.

In 1912, one could buy a round trip ticket from Alton to St. Louis for 90¢ or to East St. Louis on another line for the same price. One way cost 45¢. The East Side System dispatched cars hourly to the nearby cities of Edwardsville, Collinsville, O'Fallon, Belleville, and Lebanon. F. M. Kirby and Company published this postcard. (Courtesy of Madison County Historical Society.)

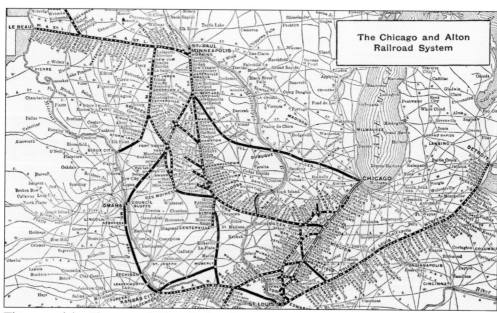

The Chicago and Alton Railroad System

This map of the Chicago and Alton Railroad was printed in the *Gazetteer of American Railroads*, showing connections with Chicago, Detroit, St. Louis, Kansas City, Omaha, and St. Paul. With the construction of a pivot span railroad bridge in 1894, Alton offered local service across the river to provide a link between Illinois and Missouri transportation. (Courtesy of Cheryl Eichar Jett.)

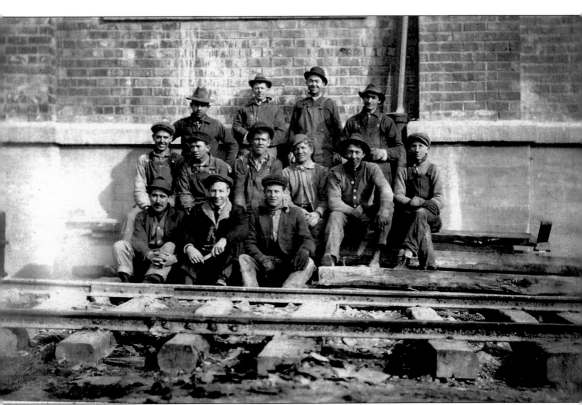

Railroad crews such as this one labored to build and maintain tracks. Seated on the far right is Charles Harris, whose family of brothers and uncles worked at utility company, railroad, and other skilled blue-collar jobs. Irish immigrant laborers had found track work beginning in 1848 under Capt. Benjamin Godfrey's supervision. (Courtesy of Suzi Journey.)

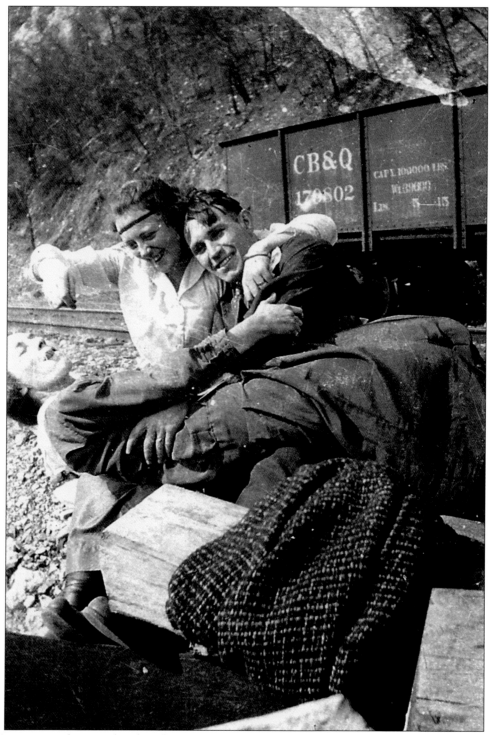

A quiet area along a railroad track provides the backdrop for some clowning by an Alton woman, Dolly Jones Harris (left bottom), and her friends. Note the Chicago, Burlington and Quincy (CB&Q) Railroad coal car behind them. (Courtesy of Suzi Journey.)

Four

THE CIVIL WAR

Alton has a volatile Civil War history, bloodied by murder and stained by disease and deplorable prison conditions. Yet Alton's Civil War legacy is also inspired and inspiring because of its strong antislavery activity and its community strength and spirit in supporting the daring capture of arms from the St. Louis Arsenal led by Capt. James H. Stokes.

The murder of abolitionist newspaper publisher Elijah Lovejoy in November 1837 gave Alton an early start to the Civil War. The event also capped off the year of the national financial panic and the resulting economic downturn, from which Alton suffered for several years before the new railroad lines brought commercial enterprise to the community again.

Lovejoy published an abolitionist newspaper, the *Observer*, in St. Louis, but facing stiff opposition there, he moved his operation across the river to Alton. By November 1837, angry mobs had destroyed Lovejoy's printing presses three times. When a fourth press was delivered to the Godfrey, Gilman and Company warehouse, an armed mob soon assembled. Although men stayed with Lovejoy to protect the press and the building, they could not hold off the mob. Someone climbed a ladder to set the roof on fire. When Lovejoy exited the building he was shot five times and died soon after. No person was ever charged or tried for the murder.

Alton was an important city in the Underground Railroad network from Alton north through Jacksonville, Pittsfield, and Quincy. Stations in Alton included the Old Rock House, the Enos Sanitarium, and the Ursuline Convent. There are also several documented stops in Upper Alton, mostly private homes. Alton Underground Railroad conductors included James P. Thomas, Isaac Kelley, and Maj. Charles Hunter, an Alton developer.

Some free blacks lived in the area as early as the 1820s. In 1840, Alton was one of four towns outside of Chicago that had a black population of around 100. The founding pastor of Union Baptist Church was John Livingstone, Lovejoy's pressman. In 1845, the Illinois State Supreme Court made a decision in *Jarrot v. Jarrot* that descendants of French slaves born after 1787 could not be held as slaves, effectively concluding the slavery issue for the state.

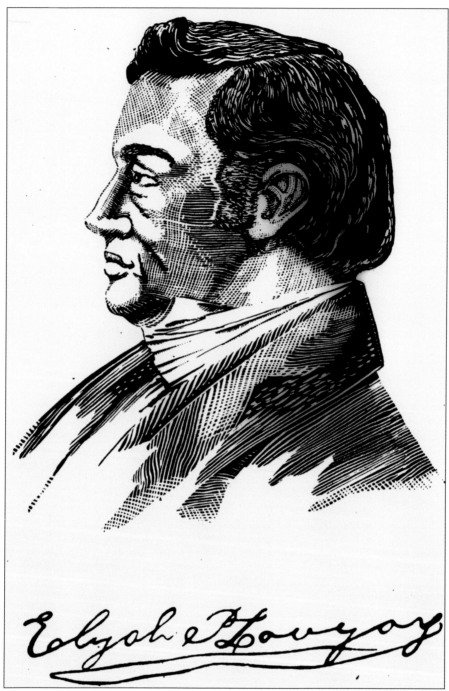

Elijah Lovejoy was born in Maine in 1802. After graduation from Colby College, he eventually came to St. Louis where he worked for a newspaper. After returning to the East for a divinity degree from Princeton Theological Seminary, he came back to St. Louis where he established the *St. Louis Observer*, an antislavery publication. When his unpopular views forced his leaving St. Louis, he moved across the river to Alton where he began the *Alton Observer*. (Courtesy of Donald J. Huber.)

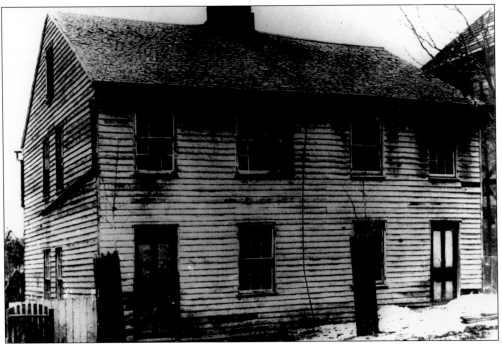

During his brief time in Alton, Lovejoy lived in this house on Cherry Street, between Second and Third Streets. The only property owner in Alton who would rent rooms to Lovejoy was Maj. Charles Hunter, a major developer and Underground Railroad conductor. The area became known as Hunterstown, where some free blacks also lived. (Courtesy of Donald J. Huber.)

The Upper Alton Presbyterian Church was organized early in 1837 with Lovejoy as the first pastor. The original stone building was built in 1837 on land donated by Enoch Long. That building burned in 1858 and was replaced with the frame building shown here. In 1925, the name College Avenue Presbyterian Church was adopted. A large stone building replaced this one in 1927. Lovejoy preached in other communities in addition to Alton. (Courtesy of Madison County Historical Society.)

The Old Rock House on the corner of Clawson and College Avenues is located across the street from Elijah Lovejoy's Presbyterian church. Here Alton's antislavery society organized and met just days before Lovejoy's murder. The 1834 house built of native stone was used as an Underground Railroad station. (Courtesy of Madison County Historical Society.)

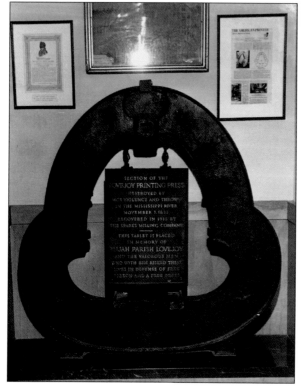

After Lovejoy was killed at the Godfrey, Gilman and Company warehouse, the mob demanded that the press be handed over. It was destroyed, and the pieces were thrown into the river. Years later, a portion of the press was retrieved from the river when the channel was being dredged and is now on display in the Telegraph newspaper office. (Courtesy of Donald J. Huber.)

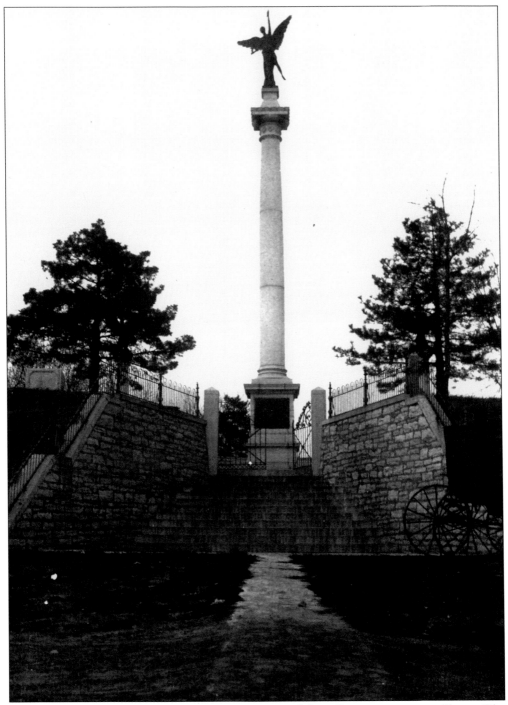

At 93 feet tall, the Elijah Lovejoy Monument is one of the tallest monuments in Illinois. The monument and Lovejoy's grave are located in the Alton Cemetery. Alton mayor and later state senator Charles Herb was instrumental in finding funding for the monument, which was dedicated in 1897. Lovejoy's gravestone was not set until 1864. (Courtesy of Donald J. Huber.)

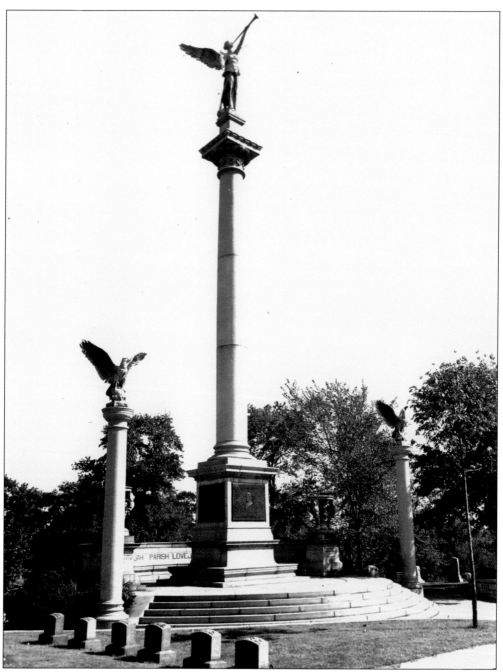

A free black man, William "Scotch" Johnston, a stonecutter who had worked on the St. Louis Cathedral, buried Elijah Lovejoy. In 1864, when Lovejoy was reinterred, Johnston was the only person who knew the new burial site. Isaac Kelly, an Underground Railroad conductor, became trustee of the Lovejoy grave site. Since then Alton's African American community has kept Lovejoy's memory alive; a memorial service is held annually on November 9 at the Elijah Lovejoy Memorial. (Courtesy of Donald J. Huber.)

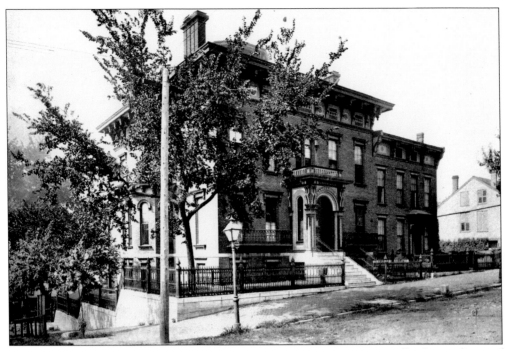

The Enos Sanitarium, later known as the Enos Apartments, was originally the residence of Nathaniel Hanson. When Dr. Joseph W. Enos purchased the Italianate-style home, he added a third floor for his sanitarium by raising the roof, cupola, and eaves. The foundation of this building is at least 15 feet below street level with passageways and rooms, suggesting use as an Underground Railroad stop. (Courtesy of Donald J. Huber.)

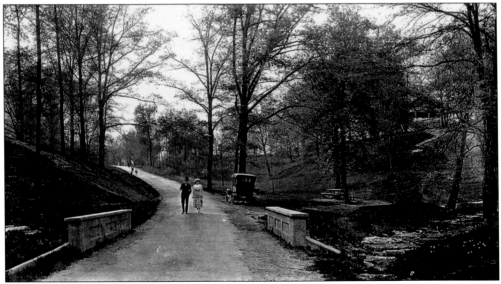

In the 1840s, an area near Rock Springs Park in Upper Alton was used for encampment of Mexican War soldiers. Ladies of the area baked pies and brought them to the soldiers, giving the area the name Pie Town. Civil War soldiers who camped there were also said to have been given food. Upper Alton is still known as Pie Town. The area's Memorial Day parade, one of the first in the country, annually honors veterans. (Courtesy of Donald J. Huber.)

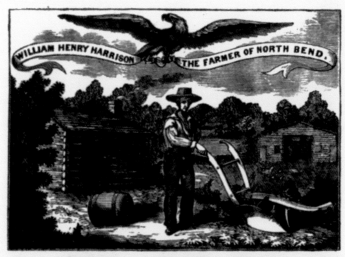

PUBLIC

MEETING.

A general MEETING of the friends of

HARRISON & REFORM,

In the City of Alton will be held at the ☞ *Old Court Room, Riley's Building* ☜ on THIS EVENING, the Ninth inst., at Seven o'clock, to make arrangements for the approaching Convention at Springfield on the Fourth of June next.
 Alton, May 9, 1840.

In 1840, this illustrated political flyer announced a public meeting of "the friends of Harrison and Reform" in Alton on May 9 "to make arrangements for the approaching Convention at Springfield." A streamer unfurls from the eagle's claws with the slogan "William Henry Harrison. The farmer of North Bend." William Henry Harrison's campaign symbols of a log cabin and a jug of cider are displayed, while Harrison himself is dressed as a farmer. (Courtesy of Library of Congress.)

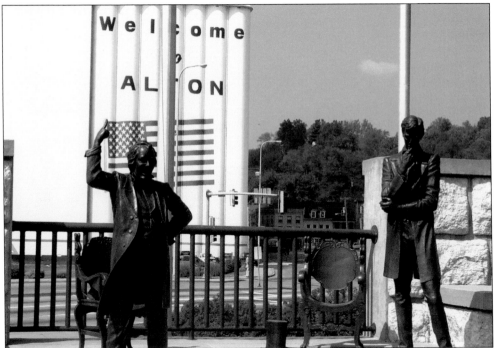

Abraham Lincoln and Stephen A. Douglas came to Alton for their seventh debate on October 15, 1858. An audience of 6,000 assembled for this, their final debate in their campaign for election to the United States Senate, on a platform constructed in front of the new city hall at the corner of Broadway and Market Streets. It was said that Douglas had such a sore throat that he could hardly speak by the time the debate ended after three and a half hours. The city hall was destroyed by fire in 1924. The life-size statues of Lincoln and Douglas were dedicated in 1995. (Photographs by Jamison O'Guinn, courtesy of Alton Regional Convention and Visitors Bureau.)

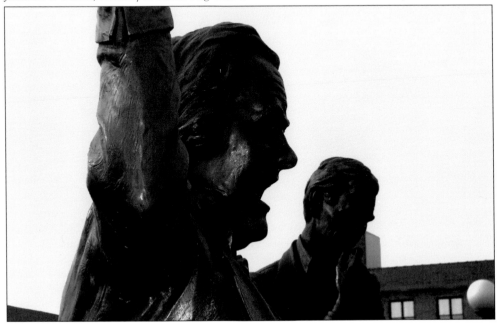

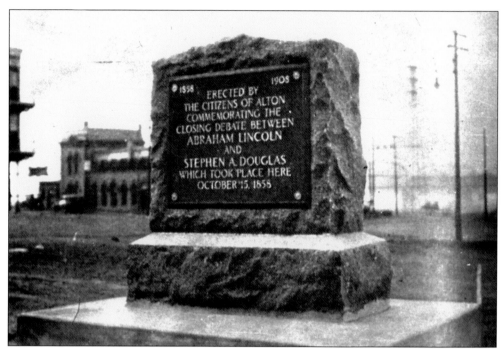

The Lincoln-Douglas commemorative bronze plaque was originally placed on the old city hall in 1908. That year, a committee organized a 50-year-anniversary celebration of the Lincoln-Douglas debate, complete with parade, pageant, and fireworks. When the building burned in 1924, the plaque was affixed to a granite marker. (Courtesy of Madison County Historical Society.)

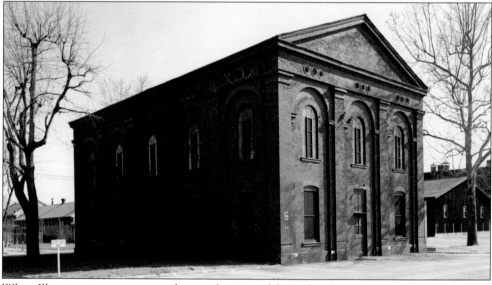

When Illinois regiments requested arms, they were delivered to the St. Louis Arsenal. Knowing of secessionist sentiment in St. Louis, Capt. James H. Stokes employed a daring plan to obtain the muskets and load them onto the *City of Alton*. When the steamboat arrived at the Alton riverfront, volunteers swarmed the riverfront to unload the precious cargo and load it onto a railroad train. By morning the train was on its way to Springfield. (Photograph by Paul Piaget, courtesy of Library of Congress.)

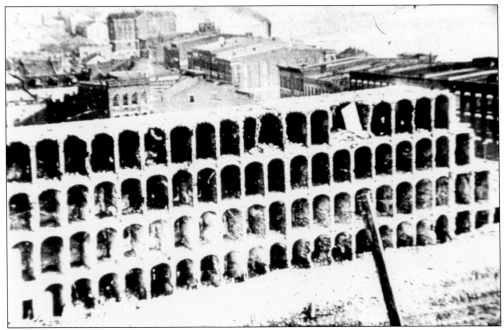

The Illinois State Penitentiary was completed in the 1830s but later closed due to its deplorable conditions. It was reopened to serve as a Confederate prison during the Civil War. During that use, more than 1,300 soldiers died there, mainly of smallpox and other diseases. One temporary prisoner was Dr. Thomas Hope, former Alton mayor, who was incarcerated for his secessionist views. While there, he tended to ill and dying prisoners. (Courtesy of Alton Regional Convention and Visitors Bureau.)

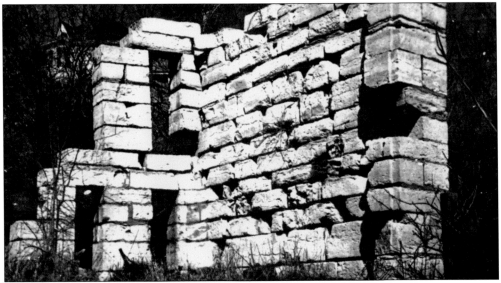

The Confederate prison was closed for good in July 1885 when the final remaining prisoners were sent to St. Louis. After stones had been taken from the site for many years, in the 1970s, the few remaining stones of the prison walls were reassembled into this partial wall located at the corner of William and Broadway Streets. The prison originally occupied the entire block. (Courtesy of Donald J. Huber.)

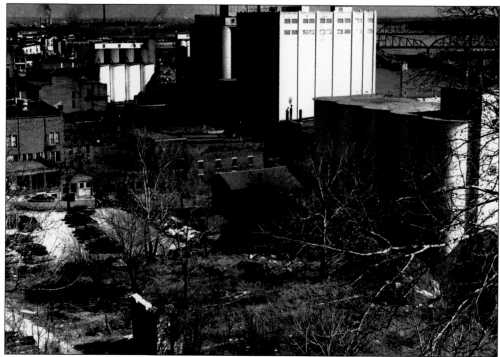

This 1952 photograph shows a remaining wall portion of the Confederate prison on the hill near Broadway Street. To the right the river and bridge are visible. Past the parking lot the downtown area begins and beyond that (back left) the smoke from American Smelting and Owens-Illinois, Inc., (formerly Illinois Glass Company) can be seen. (Courtesy of Donald J. Huber.)

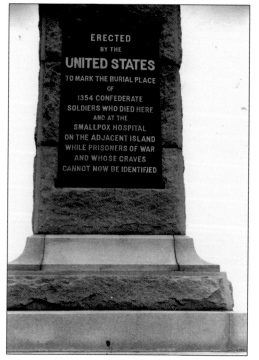

The plaque on the Confederate monument reads, "Erected by the United States to mark the burial place of 1354 Confederate soldiers who died here and at the smallpox hospital on the adjacent island while prisoners of war and whose graves cannot now be identified." An ornamental iron fence and entrance gates were also erected. (Courtesy of Madison County Historical Society.)

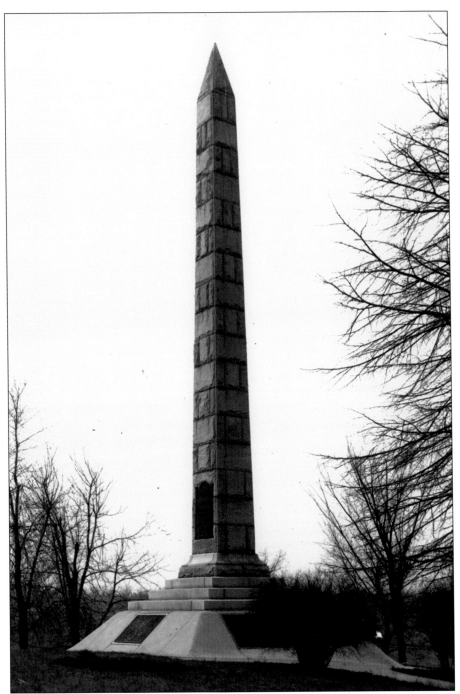

The Confederate monument in honor of the Southern soldiers who died in Alton is located in the Rozier Street Cemetery just off State Street. The cemetery was neglected for many years until the Sam Davis Chapter of the Daughters of the Confederacy began an effort to restore the cemetery. In 1909, the obelisk of granite blocks was erected, with four bronze plates at the base bearing the names of those known to have died in prison. (Courtesy of Madison County Historical Society.)

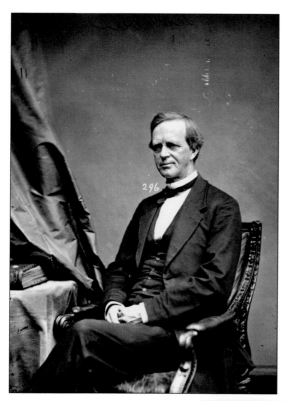

Lyman Trumbull served as a United States senator from Illinois during the Civil War era. He was born in Connecticut, studied law, and practiced law in Georgia before moving to Belleville, Illinois. Trumbull served as representative, senator, and secretary of state and chaired the Senate Judiciary Committee. In 1864, he introduced a bill that led to the 13th Amendment. (Courtesy of Library of Congress.)

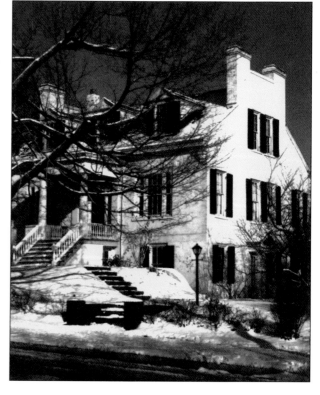

While residing in Alton from 1849 through about 1863, Trumbull lived in this house at 1105 Henry Street, which was built between 1820 and 1837. The one-and-a-half-story brick home was placed on the National Register of Historic Places in 1975 and is in very close to its original condition. (Courtesy of Madison County Historical Society.)

Five

THE INDUSTRIES
AND THEIR WORKERS

By the 1870s, Alton was poised for industrial and commercial growth. With plentiful natural resources in the area, the adjacent river, and the railroad lines linking to major cities including Chicago, Alton was a natural choice for industry. In addition, hundreds of German, Swiss, Irish, and English immigrants provided a workforce for the expanding factories. Alton had a new city hall, two daily newspapers to keep its citizens abreast of national and world events, several banking establishments, and had distanced itself from the Elijah Lovejoy murder and the 1837 financial panic.

Some factories and commercial enterprises had well established themselves in the 1840s. Nathaniel Hanson had begun the Alton Agricultural Works in 1841, selling farming implements and employing close to 100 workers. It was the largest farm implement business in Illinois outside of Chicago. Breweries had begun when German immigrants Philip Yakel and Jacob Haas arrived in Alton.

During the 1860s, entrepreneurs John J. Mitchell, William H. Mitchell, and Z. B. Job invested in the Chicago and Alton Railroad, the Alton–St. Louis Packet Company, and a St. Louis railroad connection. Their investments ensured shipping capability by both river and railroad and cemented connections between Alton and St. Louis and between Alton and Chicago on to the East and upper Midwest.

John E. Hayner established the Alton Box Manufacturing Company in 1872 and also purchased a small glassmaking establishment. He sold the glassmaking enterprise to two men, Edward Levis and William Smith, who had capital and business experience, but no glassmaking expertise. However, the company expanded quickly and eventually became Alton's largest industry, although not without troubles along the way. Child labor issues, union organizing, and lawsuits charging fraud brought national issues into play.

The Hapgood Plow Company, established in 1873, developed two kinds of plows that were soon being shipped around the world. Another notable industry that began during this time period was Franklin Olin's Equitable Powder Company, begun in 1892 to manufacture black powder for use in coal mines. In 1898, Olin founded the Western Cartridge Company, producing shotgun ammunition.

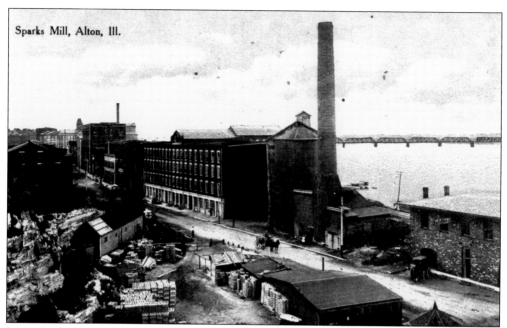

In 1882, the Sparks Mill could produce as much as 500 barrels of flour in a day. The Alton City Mills boasted it could produce 700 barrels a day. The Alton City Mills was established by Silas W. Farber and Henry Guest McPike, but was soon purchased by E. O. Stanard and Company. There were two other flour mills in the area at that time, the Empire Mill and the Madison Mills. (Courtesy of Madison County Historical Society.)

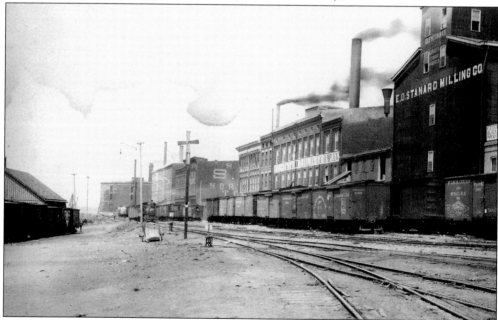

The E. O. Stanard Milling Company shown in this 1894 photograph was the largest in Madison County in 1881. The mill continued to produce hundreds of barrels of flour per day with the help of 31 employees. The railroad lines adjacent to the company enabled an efficient shipping process. (Courtesy of Donald J. Huber.)

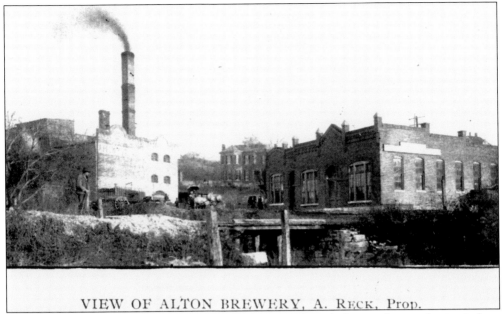

VIEW OF ALTON BREWERY, A. RECK, Prop.

Anton Reck relocated the Alton Brewery at 215 East Fifteenth Street after purchasing it from John Jehle in 1890. In 1894, a fire broke out, possibly from a smokestack spark. Disaster was averted when city firefighters arrived and doused the blaze after employees' attempts had failed. In the 1890s, telephone service arrived in Alton and the Alton Brewery number was listed as 13. (Courtesy of Donald J. Huber.)

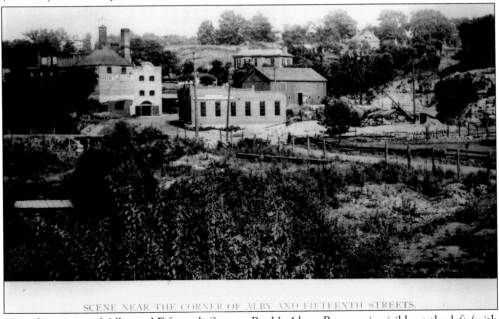

SCENE NEAR THE CORNER OF ALBY AND FIFTEENTH STREETS.

Near the corner of Alby and Fifteenth Streets, Reck's Alton Brewery is visible at the left (with smokestack). The business prospered. Annual sales exceeded 10,000 barrels by 1906. An artesian well, building additions, and modern machinery and equipment kept business booming. In June 1913, the brewery's own previous records were broken when 7,186 bottles were filled in one day. (Courtesy of Donald J. Huber.)

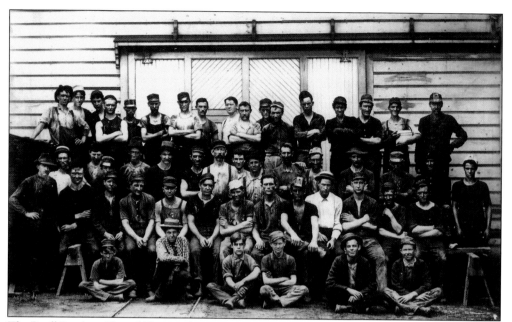

The Beall Brothers Shovel Shop workers pose for a picture. The Beall brothers, Edmond and J. W., owned three factories, two in Alton and one in East Alton, manufacturing hardware, railroad tools, and mining supplies. In 1907, just seven years after incorporating, they were ranked the largest producer of heavy equipment in the United States. (Courtesy of Mark Bohart.)

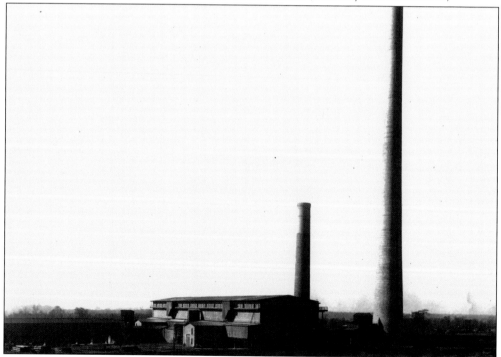

The smokestack for the Federal Lead Company was 450 feet tall, built on an octagonal base with an 84-foot diameter, and cost approximately $200,000 to build. In 1928, it was considered to be the fourth-tallest smokestack in the United States. (Courtesy of Madison County Historical Society.)

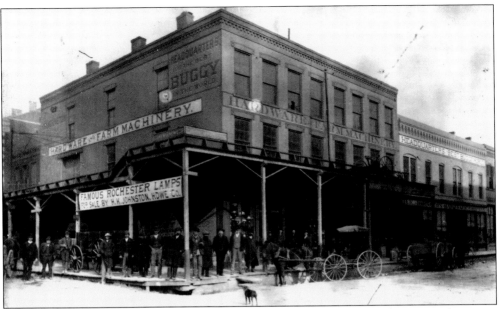

The H. K. Johnston Hardware Company was located at 144 to 150 Second Street at the corner of Second and State Streets. The company stocked paint, harness, and general hardware in its large retail store. The corner of the building was known for the flood marks recorded on it, and a crowd generally gathered at that corner when water was inching its way up Alton streets. (Courtesy of Donald J. Huber.)

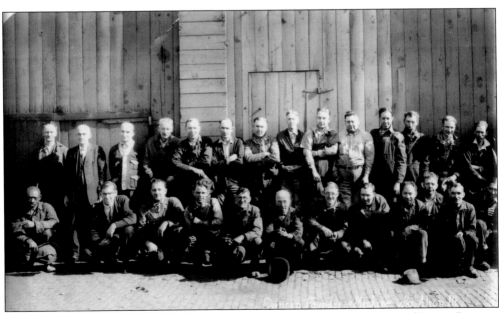

Duncan Foundry workers line up for a photograph. In 1874, Gilbert Duncan and Brutus Brunner opened a machine shop and iron foundry, manufacturing coal mine cars and other mining equipment for the burgeoning coal industry. Later Brunner sold his interest to the Duncan family. The foundry occupied several blocks and grew to become one of Alton's major industries. (Courtesy of Mark Bohart.)

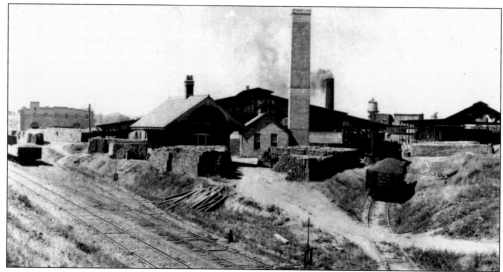

The Alton Brick Company was started and built up slowly by a Wood River Township farmer, Edward Rodgers, in 1854. By 1892, stock in the company was issued and Rodgers became president. High-quality building and paving bricks were manufactured until the mid-1950s, when the company was sold to an out-of-state buyer, and the business was moved to St. Louis. The brick works site later became the Alton landfill. (Courtesy of Donald J. Huber.)

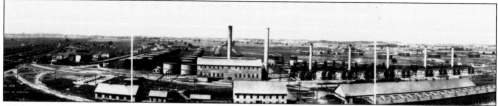

Although the Wood River Refinery was not established in Alton, the City of Alton promoted it as one of its top industries. In *Reid's Brochure of a Notable American City: Alton Illinois*, George H. Mosser, secretary of the Alton Board of Trade, stated enthusiastically, "Alton has industrial characteristics which make it stand high among cities of the Middle West. It boasts of the largest oil refinery in the Mississippi Valley and the biggest hollow-ware glass plant in the world." (Courtesy of Library of Congress.)

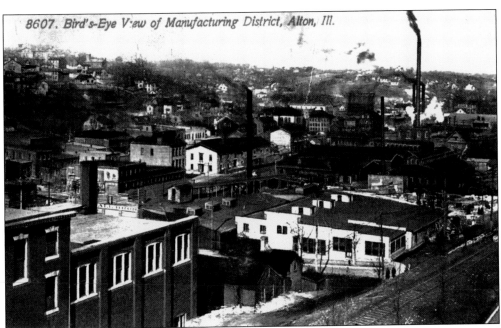

A bird's-eye view of the manufacturing district shows the smokestacks pumping out exhaust and smoke from the plants. This contributed to a distinctively poor quality of air for many years. Glass, lead, iron, steel, grain, black powder, and oil production all added to the polluted mixture in the air. (Courtesy of Madison County Historical Society.)

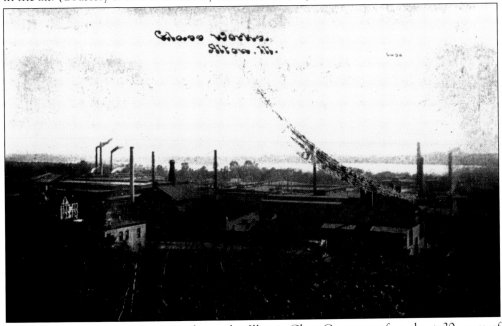

A postcard from the early 1900s shows the Illinois Glass Company after about 30 years of growth and expansion. The plant had about 2,200 employees in 1890. By 1896, the company had expanded in size to 10 glass houses. The workforce had expanded to 4,000 by 1912. The company merged with Owens Bottle Company in 1929 to become Owens-Illinois, Inc. (Courtesy of Madison County Historical Society.)

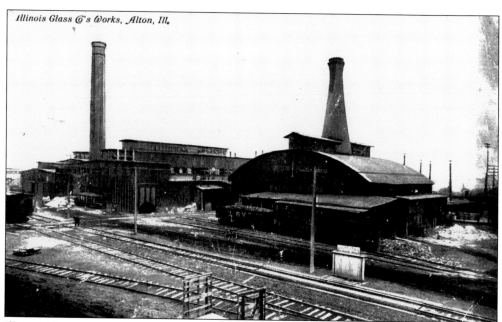

Illinois Glass Co's Works, Alton, Ill.

Illinois Glass Company's location had limited access to railroad lines. Local investors including Edward Levis and William Smith incorporated the Illinois Terminal Railroad in 1895, completing a line in 1900. This link provided full shipping facilities for Illinois Glass Company in addition to other industries. (Courtesy of Madison County Historical Society.)

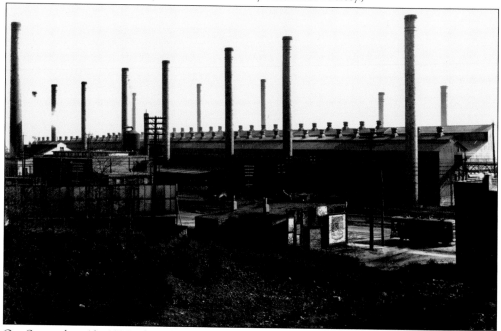

On September 13, 1908, the *New York Times* stated, "The United States Grand Jury here [Quincy] today returned joint indictments against the Illinois Terminal Railway Company and the Illinois Glass Company of Alton for alleged frauds in transcontinental shipments." The case was heard in Springfield. The company's success was undeterred. (Courtesy of Madison County Historical Society.)

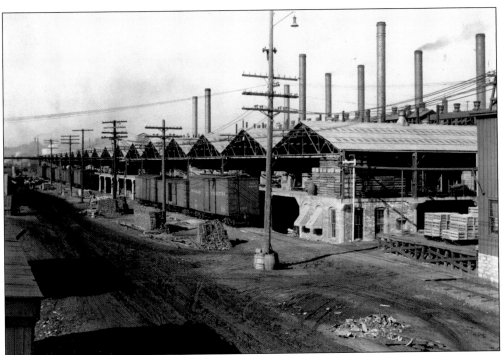

In 1907, Crawford Fairbanks and Thomas Bauer transplanted their paperboard factory from Indiana to Alton. They purchased land along the river for their business, newly named the Alton Box Board and Paper Company. They also bought experimental paperboard machinery, but their risks paid off, and the company became extremely profitable. (Courtesy of Madison County Historical Society.)

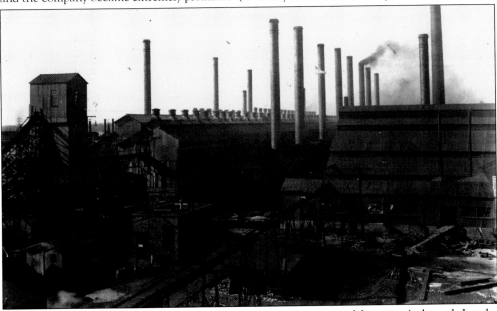

This photograph shows the batch plant, glass-producing houses, and factories A through J at the Illinois Glass Company. Many of these facilities were built or rebuilt over a 15-year period. By the time of this photograph, all the smokestacks were the modern, linear type. The last bottle-shaped smokestack was torn down in 1913. (Courtesy of Madison County Historical Society.)

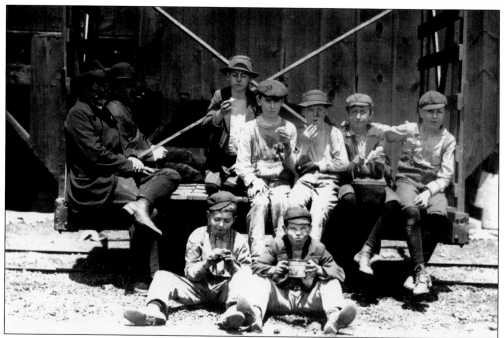

In 1907, Lewis Wickes Hine became the photographer for the National Child Labor Committee and traveled the United States documenting instances of child labor through photographs and notes, such as this group of boys on their lunch break at the Illinois Glass Company in May 1910, "on Tuesday at noon." (Photograph by Lewis Wickes Hine, courtesy of Library of Congress.)

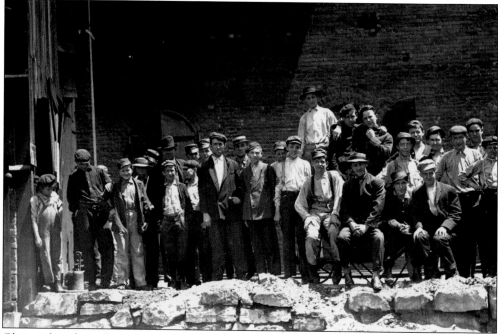

Glassworkers from shops 6 and 7 at Illinois Glass Company gathered for a picture in May 1910. The small boy at the far left was a Polish immigrant and, according to Hine's notes, could not speak English. (Photograph by Lewis Wickes Hine, courtesy of Library of Congress.)

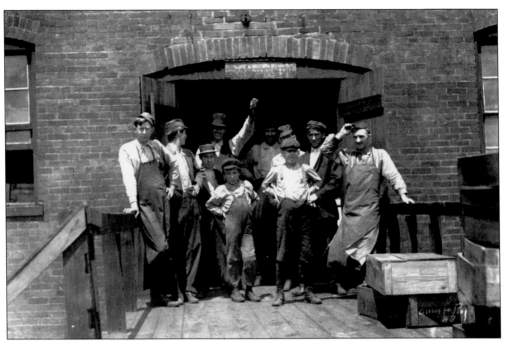

This group of employees worked in Illinois Glass Company's shop 6. At center front is the little Polish boy. Hine worked for the National Child Labor Committee for 10 years, photographing child workers at a dozen glassworks and other industries. (Photograph by Lewis Wickes Hine, courtesy of Library of Congress.)

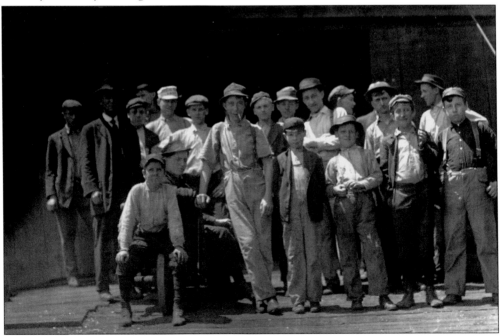

Glassworkers from shop 7 at Illinois Glass Company pose for this photograph in May 1910. Hine also photographed at glassworks in New Jersey and West Virginia. (Photograph by Lewis Wickes Hine, courtesy of Library of Congress.)

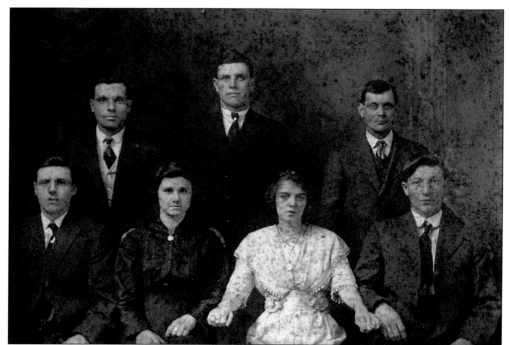

The Harris family was a typical working-class, close-knit Alton family with deep roots in the area; this photograph shows the third generation of Harris Altonians, sons and daughters of James Russell Harris and Ida Belle Harris. From left to right are (first row) Edward, Viola, Grace, and Charles; (second row) James B., William, and George. These five brothers all lived and worked in Alton throughout their lives. (Courtesy of Suzi Journey.)

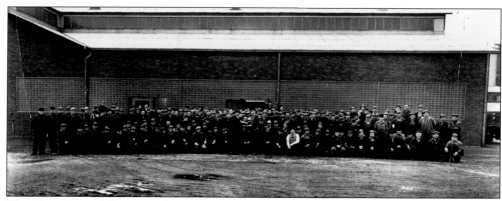

The Alton Gas and Electric Light Company was begun in 1855 and employed a sizable workforce. An early job description of many of the workers was that of "gas maker." James B. worked at the utility company for 42 years, beginning in 1896 as a gas maker and retaining that job until it was phased out in 1926. He worked another 10 years as a watchman before retiring. (Courtesy of Suzi Journey.)

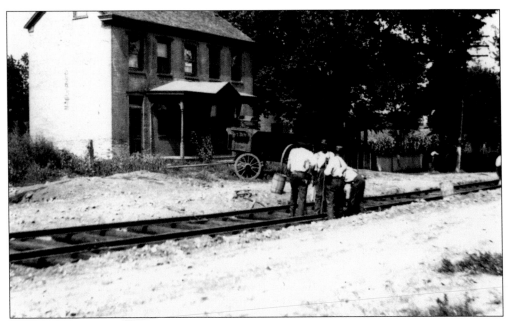

As in many cities, working-class families often lived near railroad tracks. This was the home of the Peterson family at 3416 College Avenue, pictured about 1918. In the picture below, on the porch are, from left to right, an unidentified neighbor boy; Marvin Peterson (standing); his mother Annie Peterson of Crosby, North Dakota; Marvin's daughter Florence; and Marvin's son Robert. A family member recalled that the brick building (left) beside the house in the picture below was called "the old brick" and belonged to the Coca-Cola Company. The home was later torn down, and an automotive service and tire dealer now occupies the address. (Courtesy of Madison County Historical Society.)

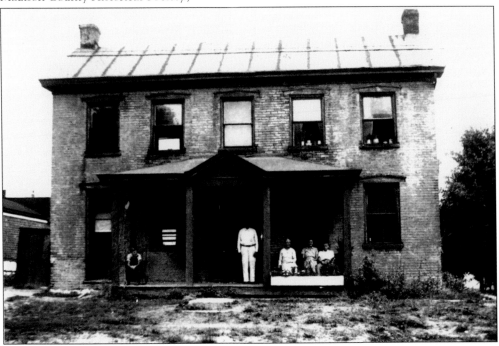

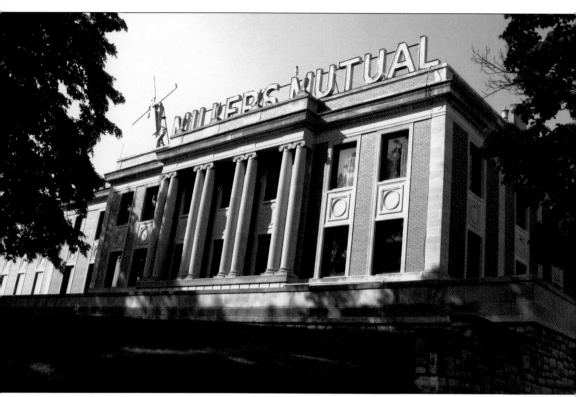

Millers Mutual Insurance Company was first established in 1877 and insured many of the industries in Alton. Later the company also offered insurance to individuals and retail businesses. In 1921, its initial building was constructed on the site of the G. W. Hill home at Fourth and Easton Streets. Its trademark windmill sits atop the present building, which faces on Third Street. (Photograph by Cheryl Eichar Jett.)

Six

THE GILDED AGE

Mark Twain gave the name *Gilded Age* to the period of the late 1800s when America's cities experienced major population and industrial expansion, the upper class exhibited displays of wealth, and philanthropy was on the rise. During the second Industrial Revolution, the working class produced wealth for the upper class. In the best-case scenarios, the upper class responded with contributions of money and land for public buildings including libraries, hospitals, and other edifices. Alton reflected this phase of American growth in its explosion of industry, construction of magnificent mansions, and establishment of public buildings.

By this period, Alton had its full share of industrialists, entrepreneurs, bankers, investors, and insurance men. One man who characterized the age and became one of its most prominent citizens arrived in 1857. His name was Lucas Pfeiffenberger, the son of German immigrants who gave Pfeiffenberger an excellent education as he grew up in Ohio. As a young man, Pfeiffenberger traveled to California during the gold rush, spent some time in the goldfields, and later returned home to Ohio. On a second trip to California, he stopped in Alton and liked what he saw. His construction and architectural expertise was soon put to work, and he became widely known. Pfeiffenberger's designs included many of Alton's mansions and public buildings.

Contributions from prominent and wealthy citizens enabled the Alton Women's Home, the Young Men's Christian Association (YMCA), and the Young Women's Christian Association (YWCA) to be established. Jennie Hayner, wife of John E. Hayner, worked to further the Alton Library Association. When she died in 1888, her husband funded and built the Hayner Public Library as a memorial to her.

Another woman from a prominent Alton family, Alice Smith dreamed of a modern full-service hospital. Smith was the widow of William Smith, one of the founders of the Illinois Glass Company. After her death, her two daughters, Eunice Smith and Ellen Smith Hatch, fulfilled their mother's dream. Establishing the hospital as a memorial to their parents, the daughters assisted when ground was broken in 1936 for Alton Memorial Hospital.

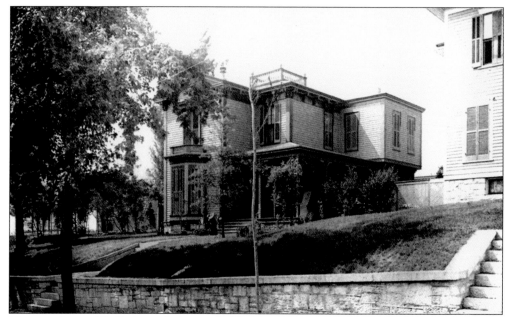

This was Lucas Pfeiffenberger's design for his own home, built on State Street around 1868. Pfeiffenberger left a long record of community service, as he had served as head of the fire department and four-term mayor. He helped to organize the Alton Board of Trade and served as its president. He served as president of several banks and the Building and Loan Association, which he established. Pfeiffenberger died in 1918 at the age of 83. (Courtesy of Donald J. Huber.)

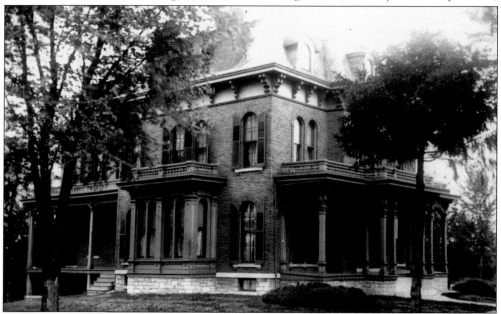

Henry Guest McPike built this elaborate mansion on Alby Street in 1869 on a 15-acre site he called Mount Lookout. McPike served as mayor and was involved in various business enterprises, including real estate, box manufacturing, and insurance. He was an avid horticulturist and graced his property with flowers, orchards, shrubs, and rare trees. Haunted tours are offered in this magnificent old mansion. (Courtesy of Donald J. Huber.)

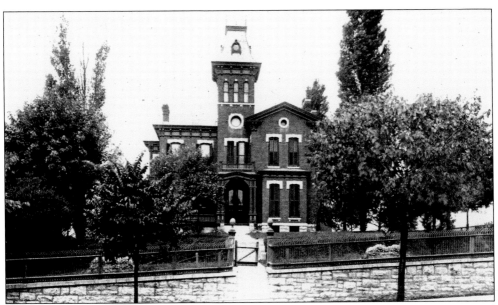

This Second Empire/Italianate mansion was designed for Henry Watson by Pfeiffenberger and built on Alby Street. Watson had emigrated from England and operated two stone quarries. The terrace and yards around the home were raised with fill from one of Watson's quarries. Watson also was a co-owner of the Alton Water Works. (Courtesy of Donald J. Huber.)

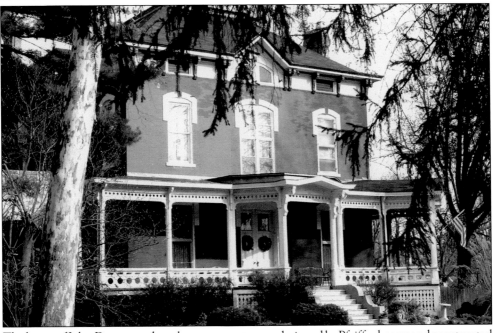

The home of John Drummond, a tobacco magnate, was designed by Pfeiffenberger and constructed on Twelfth Street between 1882 and 1885, taking three years to complete. This huge house in Victorian East Lake style has 18 rooms, two staircases, double entrance doors, a 40-foot grand gallery, and a 24-foot dining room. It was thought to be the largest private residence in Alton and said to be Pfeiffenberger's finest accomplishment. (Courtesy of Alton Regional Convention and Visitors Bureau.)

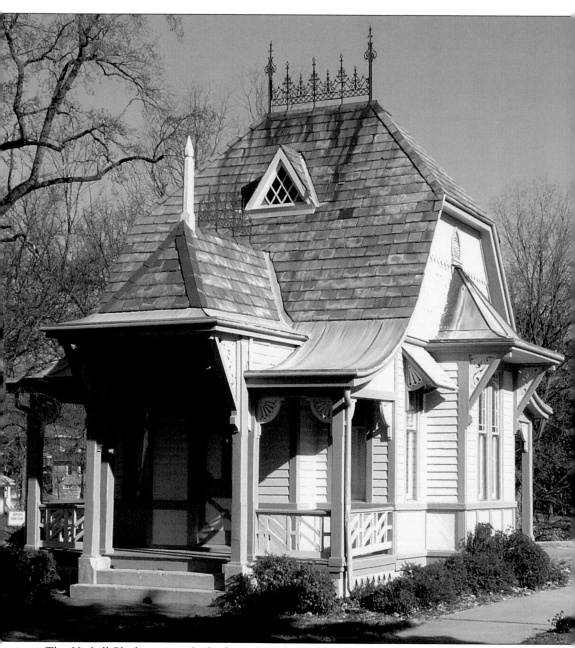

The Haskell Playhouse was built about 1880 for little Lucy Haskell with a design from Lucas Pfeiffenberger, but sadly Lucy died of diphtheria just a few years later. Her parents, Dr. William A. and Florence Haskell, eventually donated the property and the playhouse on Henry Street to the City of Alton. The Haskell home is long gone, but the property serves as a park for children as a symbol of Victorian childhood. (Courtesy of Alton Regional Convention and Visitors Bureau.)

The Koenig House at 829 East Fourth Street was built in 1887 for a German American engineer employed by the Illinois Glass Company. Another design by Pfeiffenberger, the home was lived in by generations of the same family until it was donated to the Alton Museum of History and Art. It is now maintained by the museum and, on the first floor, features a re-created setting with furnishings of the early 1900s. (Photograph by Cheryl Eichar Jett.)

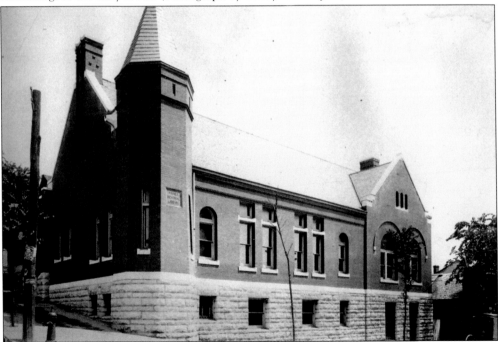

The Hayner Public Library was funded and built in 1891 on State Street by John E. Hayner after the death of his wife, Jennie, who was a director of the Alton Library Association. Today the building serves as the youth library for the Hayner Public Library District, while a new building a block away serves as the main library. Supported by private funding, the library association also sponsored concerts, dramas, and lectures. (Courtesy of Donald J. Huber.)

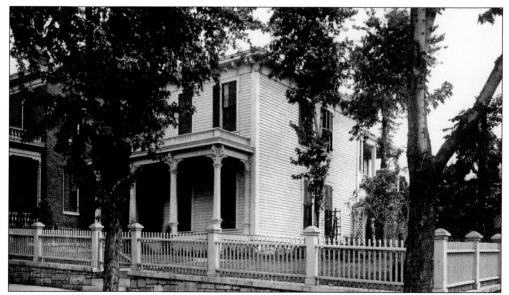

This was the home of Capt. William Leyhe, who, along with his brother Capt. Henry Leyhe and Capt. G. W. Hill, operated the Eagle Packet Company. The steamer company was one of the most well-known steamboat organizations on the upper Mississippi. In order to service its line of boats, Eagle Packet Company maintained a large warehouse on the levee at Alton. (Courtesy of Donald J. Huber.)

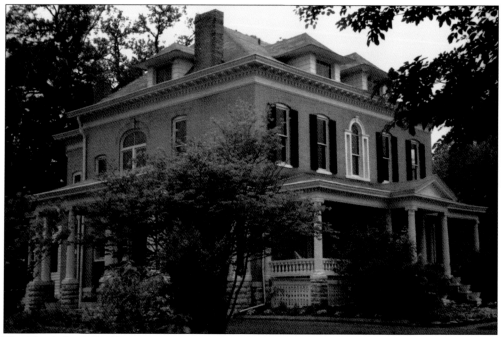

The blonde brick Beall mansion was constructed in 1903 on East Twelfth Street as a wedding gift for riverboat magnate Z. B. Job's son. In 1909, the house was purchased by Edmond Beall, who, along with his brother J. W., operated Beall Tool and Metal Products Company. J. W. served as president of the company, while Edmond served three terms as mayor and later as a state senator. The Beall mansion is now a popular bed-and-breakfast. (Courtesy of Jim and Sandy Belote.)

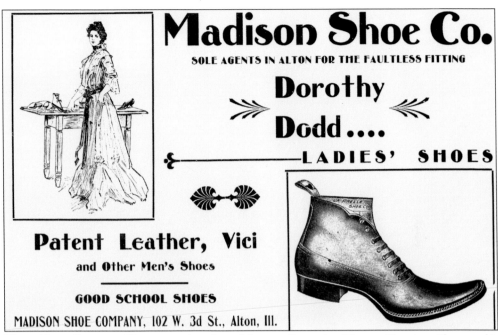

The Alton Printing House produced a 34-page *Souvenir Album: Showing Photographic Reproductions of the Great Flood June 1903*. Besides numerous pictures of the flood, John McKeon and Edward B. Clark solicited advertising to pay for the booklet. This advertisement promotes Dorothy Dodd ladies' shoes from the Madison Shoe Company at 102 West Third Street in Alton. (Courtesy of Cheryl Jett.)

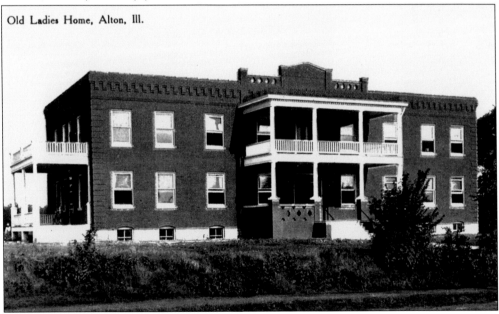

The Alton Women's Home was built in 1909 and administrated by Alton women after police matron Sophia DeMuth first advocated a home for elderly women no longer able to care for themselves. Harriet E. Root served as the board president for many years. The home was closed in 1966. (Courtesy of Madison County Historical Society.)

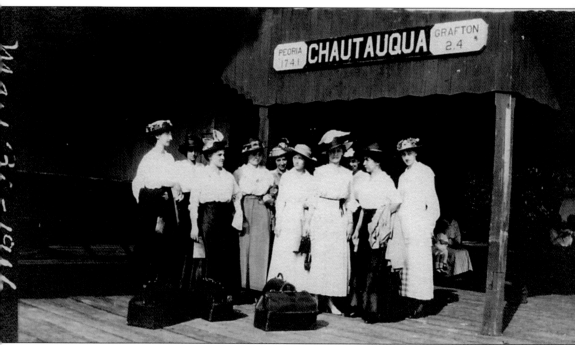

This group of women was attending the New Piasa Chautauqua north of Alton around 1910. After the success of the Lake Chautauqua, New York, performing and lecture companies, chautauquas appeared across the country, offering a variety of cultural entertainment, Bible studies, and lectures. Eventually cottages, meals, a hotel, and a place to swim and bathe were added. (Courtesy of Donald J. Huber.)

Seven

RELIGIOUS LIFE

As in most communities, Alton's religious life began soon after the town was established in 1818. Two Sabbath schools were taught in the area in 1819 and 1820. The first was organized by the wife of Rev. Thomas Lippincott and taught in their home in the nearby community of Milton, and the second was established by Henry Snow and Enoch Long in Upper Alton in May 1820. Lippincott operated a general store in Milton at Rufus Easton's request. In 1831, Lippincott founded the First Presbyterian Church in Lower Alton. Enoch Long was one of the founders of the Upper Alton (later called College Avenue) Presbyterian Church.

Two notable early religious leaders who came to the Alton area were Rev. John Mason Peck and the Reverend Dr. Augustus T. Norton. Reverend Peck, the founder of Shurtleff College in Upper Alton, was present at the organizing of the First Baptist Church in Alton in 1833. In Upper Alton, he established the Baptist church on College Avenue, considered to be the first church in Upper Alton.

The Reverend Dr. Norton became known as the "Father of Presbyterianism" in Illinois. He served in Alton as pastor from 1839 to 1859 and established many other churches in Illinois as well as Kansas and Missouri. In his later years, he published the two-volume *History of Presbyterianism in Illinois.*

Early congregations in the Alton area were mainly Baptist, Presbyterian, Episcopalian, and Methodist. Before the 1850s, there were as few as 14 Catholic families. However, as German and Irish immigrants began to arrive by the hundreds, additional Catholic congregations were established, St. Mary's and St. Patrick's. SS. Peter and Paul Roman Catholic Church became the seat of the Alton Diocese in 1857, with the Right Reverend Henry D. Juncker serving as the first bishop, but the seat was transferred to Springfield in 1923. The original Cathedral School was constructed in 1859 next to the SS. Peter and Paul Roman Catholic Church. It served as a school for boys, taught by the Brothers of the Holy Cross. In 1888, the Ursuline Sisters came to the school, and it became a free school for girls and boys.

In 1912, Alton had 21 churches of varied denominations and a total of approximately 10,000 church members.

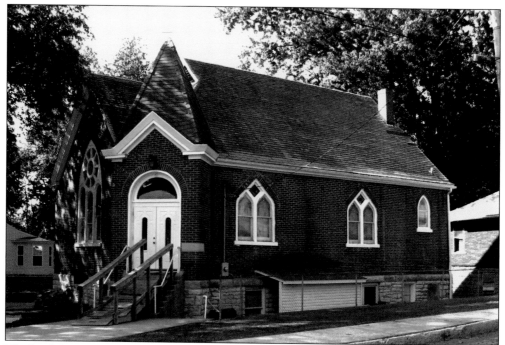

The brick Union Baptist Church, also known as the Victory Baptist Church, at the corner of Seventh and George Streets replaced a frame structure originally built on the site. Organized as the Union Baptist Church in 1836, it first met in the home of Charles Edwards. With Rev. E. Rodgers presiding, the group met in various locations until it constructed its first permanent church on this site. (Photograph by Cheryl Eichar Jett.)

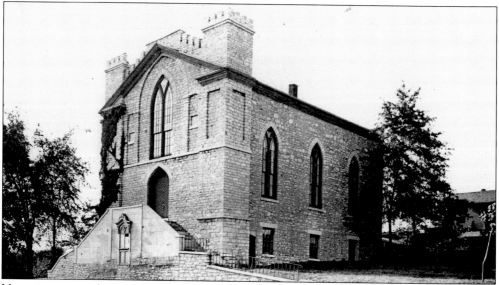

Unitarian services began in Alton about 1836, led by Rev. W. G. Eliot. A church was constructed in 1842, although the group later disbanded for a short time before reorganizing in 1853. The present First Unitarian Church was constructed in the 1850s at the corner of Third and Alby Streets, building upon the stone foundations of St. Matthew's Catholic Church on that site, which had been destroyed by fire. (Courtesy of Donald J. Huber.)

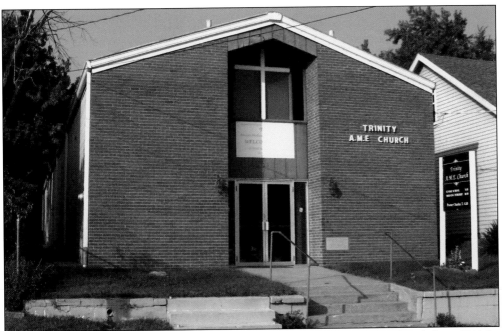

The Campbell Chapel African Methodist Episcopal (AME) Church was founded in 1844 by missionary Paul Quinn, who assisted blacks with establishing their own churches. Land for a building was donated by Colonel Hunter in the 1860s, and the church still stands on that site. It was damaged by fire in the 1970s but was renovated and is still in use. (Photograph by Cheryl Eichar Jett.)

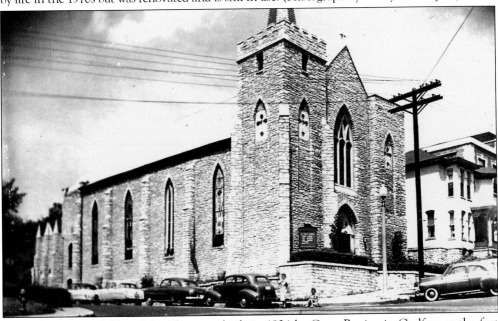

St. Paul's Episcopal Church building was built in 1834 by Capt. Benjamin Godfrey as the first house of worship in Alton; it was used by both Baptists and Presbyterians. The Protestant Episcopal church organization was founded in 1836 and purchased the meetinghouse in 1846. Rev. Thomas DePuy served as the first pastor. When Reverend DePuy left in 1887, Owen Lovejoy (brother of Elijah) served as interim lay reader. (Courtesy of the Telegraph.)

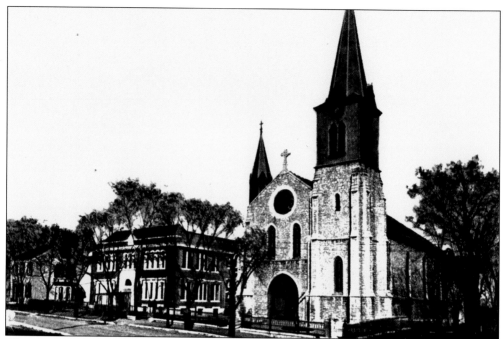

The SS. Peter and Paul Roman Catholic Church was constructed of native limestone on State Street in 1855, following the loss of the congregation's St. Matthew's Church at the corner of Third and Alby Streets by fire. In this view, the parochial school is to the left of the cathedral. The residence of the bishop was to the right (not shown). The architect was Thomas Walsh of St. Louis. (Courtesy of Madison County Historical Society.)

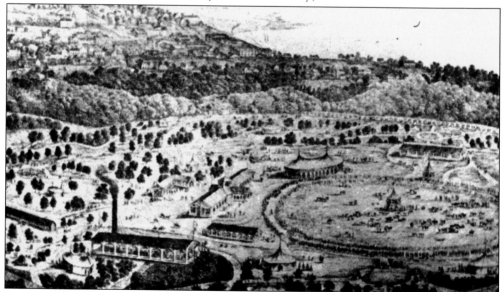

In 1856, the Illinois State Agricultural Society fair was held in Alton. This was the fourth Illinois State Fair, and it featured exhibits, steamboat races, harness racing, and a circus. The Grand Exhibition Hall and other fair buildings were designed and built by a local contractor Ezra Miller. The fairgrounds land on Danforth Street would be used a few years later as the site on which the Ursuline Convent was built. (Courtesy of Madison County Historical Society.)

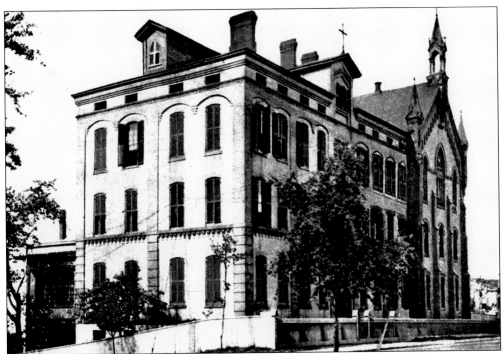

The Ursuline Academy on Fourth Street was completed in 1863. The Right Reverend Henry Juncker, bishop of the Alton Diocese, requested that the St. Louis Ursuline Order send some nuns to Alton to teach. When they arrived, they taught in classrooms set up in the Mansion House until the new building was constructed. This magnificent building was later torn down, and Marquette High School was built on the site. (Courtesy of Madison County Historical Society.)

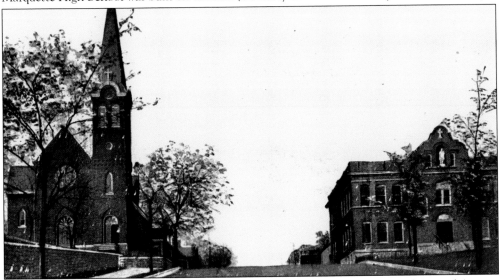

St. Patrick's Catholic Church and School at the corner of East Fourth Street and Central Avenue was the third Catholic church built in Alton. In 1973, St. Patrick's School and SS. Peter and Paul's Cathedral School merged and became known as Consolidated Catholic School. However, five years later the consolidation ended, and each parish again had its own school. (Courtesy of Madison County Historical Society.)

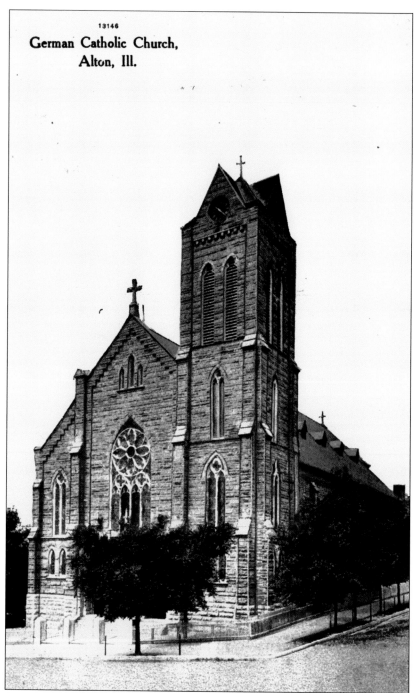

13146

German Catholic Church,
Alton, Ill.

By the late 1850s, the influx of German immigrants necessitated additional Catholic congregations. St. Mary's (German) Catholic Church was constructed at the corner of Fourth and Henry Streets in 1859. A year later, a tornado destroyed it. Unpaid debt from the building of the first church delayed replacing it, but in 1895, the present-day St. Mary's Catholic Church was constructed with Lucas Pfeiffenberger as the supervising architect. (Courtesy of Madison County Historical Society.)

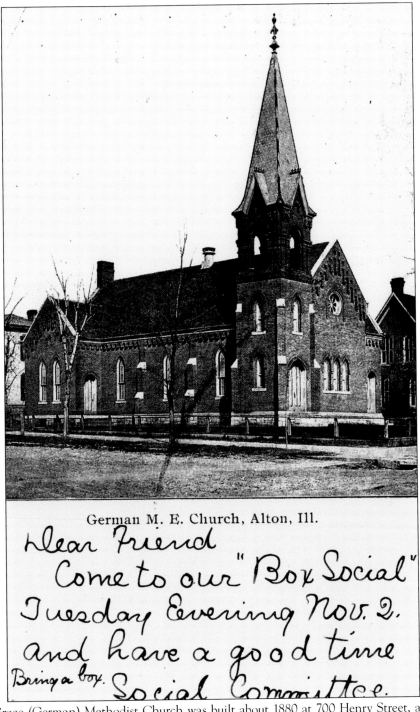

German M. E. Church, Alton, Ill.

Dear Friend
Come to our "Box Social"
Tuesday Evening Nov. 2.
and have a good time
Bring a box. Social Committee.

The Grace (German) Methodist Church was built about 1880 at 700 Henry Street, although a Methodist congregation had assembled in Alton as early as 1829. The redbrick edifice was designed by Lucas Pfeiffenberger. This *c.* 1904 photograph postcard carried a handwritten message, "Dear Friend, Come to our 'Box Social' Tuesday Evening Nov. 2 and have a good time. Bring a box. Social Committee." (Courtesy of Donald J. Huber.)

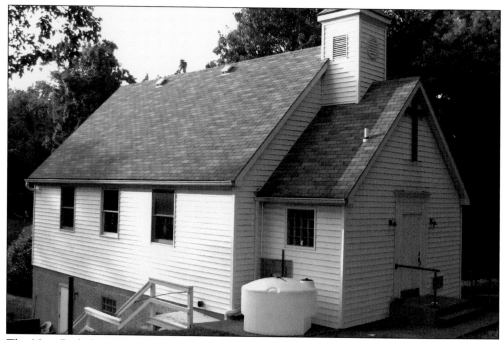

The New Bethel AME Church at Rocky Fork was the house of worship for a community of freed and runaway slaves at the small settlement, an important Underground Railroad stop. The church was established in 1863 by Rev. Erasmus Green, a freed slave. Although the church has been the target of vandalism, over the years local landowners and community leaders have assisted the church in its struggle to continue. (Photograph by Cheryl Eichar Jett.)

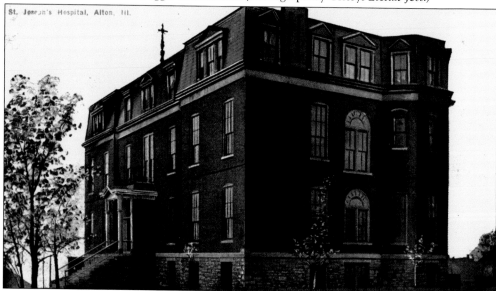

The first St. Joseph's Hospital building was constructed in 1887 at Fifth Street and Central Avenue from a design by Lucas Pfeiffenberger. However, the Daughters of Charity had first established its hospital in the Mansion House in 1865, effectively providing the first hospital in Illinois outside of Chicago. In 1901, they began a nurse training program that operated until 1973. (Courtesy of Donald J. Huber.)

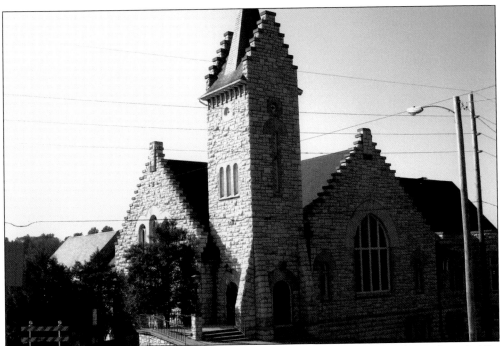

The Gothic-designed First Presbyterian Church is located at the corner of Fourth and Alby Streets and was constructed in 1897 at a cost of $30,000. The architect was Theodore C. Link, who also designed the main building of Monticello Seminary in Godfrey and the St. Louis Union Station. The church has been expanded and remodeled since its initial construction, and its bell has been used for three different Presbyterian churches. (Photograph by Cheryl Eichar Jett.)

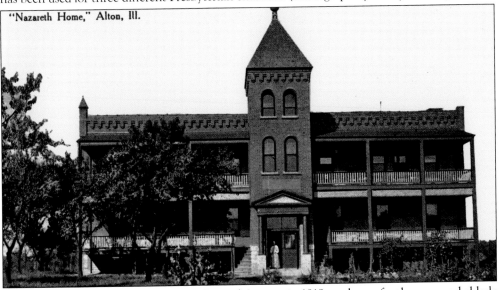

"Nazareth Home," Alton, Ill.

The Nazareth Home was built at 2120 Central Avenue in 1918 as a home for the poor and elderly who had nowhere else to go; the contractor was Henry Wardein. The Sisters of St. Francis of the Martyr St. George, an order that had been founded in Thuine, a small village in Germany, purchased the Nazareth Home in 1925. The sisters moved to Alton, renaming the institution St. Anthony's Infirmary. (Courtesy of Madison County Historical Society.)

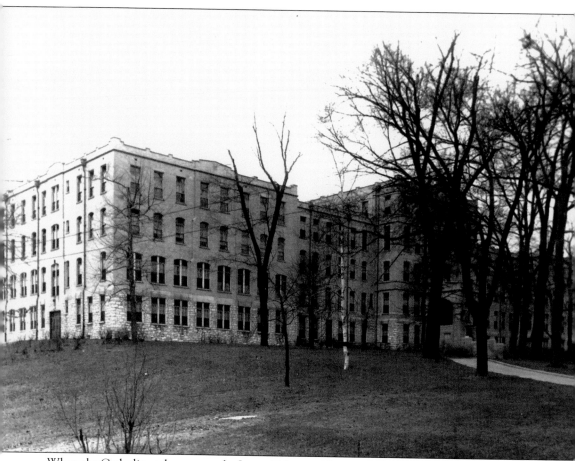

When the Catholic orphanage on the James H. Lea residence site was outgrown, the new Catholic Children's Home was built on 13 acres on State Street formerly occupied by the John E. Hayner residence. The huge edifice opened in 1923 and could house 300 children. In 1984, Nancy Reagan visited the home while on a campaign tour. The Springfield Diocese now administrates this institution, which provides special education and crisis children's programs. (Courtesy of Madison County Historical Society.)

Eight

EDUCATION

In the 1866 *Gazetteer of Madison County*, James T. Hair described the educational condition of Alton's early years: "The records of school matters are, for several years, very unsatisfactory and meager, showing that a very small measure of interest was felt in their success, or that the enterprise was prematurely undertaken. There is enough, however, to show that the fund failed, that the free schools, consequently, languished, and finally fell through, and the teachers were not paid in full."

In 1825, the Illinois state legislature passed the Free School Act, which called for counties to provide free schools for white citizens between the ages of 5 and 21. Later legislative acts dealt with the issues of establishing school districts and levying taxes to support public education.

Some records indicate that a free school was operating as early as 1821. However, most sources agree that the first free school building was constructed in 1845 at a cost of $100 for the purchase of the land and $580.70 for the construction. This was identified as school No. 2, while schools No. 1, No. 3, No. 4, and No. 5 were built within the next decade. These were followed by the Lincoln School and the Garfield School.

In 1897, the school district built two schools designated solely for use by black students. Despite a lawsuit to allow black students to attend schools in their own neighborhoods, the Alton School District remained segregated until the 1950s.

Reid's Brochure of a Notable American City: Alton Illinois painted a brighter picture in the 1912 marketing publication, stating, "From the days of the early pioneers, Alton has been a seat of learning, not only for the classes but the masses." By 1912, Alton could boast of 14 public school buildings with a staff of 112 teachers; three parochial schools, one with complete high school; two colleges; a business college; and a military academy.

The two colleges were Monticello Seminary in Godfrey, established by Capt. Benjamin Godfrey, and Shurtleff College in Upper Alton, founded by Rev. John Mason Peck. The Western Military Academy had begun its educational life as the Wyman Institute.

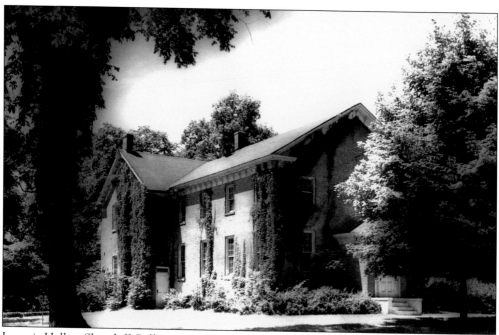

Loomis Hall at Shurtleff College was built in 1832 and is the oldest continuously used college building in Illinois. Founder Rev. John Mason Peck, convinced of the need for a seminary in the area, first established the Rock Spring Seminary in 1826 near Belleville with 27 students. In 1832, he moved the theological school to Upper Alton, establishing Shurtleff College. The Alton Museum of History and Art is now located in Loomis Hall. (Courtesy of Donald J. Huber.)

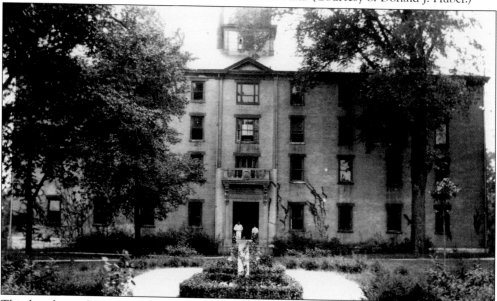

This handsome building at Shurtleff College was built in the 1840s for use as the first men's dormitory. Peck published a religious newspaper and is thought to be the pioneer of religious journalism in Illinois. In 1834, he also published the *Gazetteer for Emigrants*, which provided information for prospective settlers to the area on topics such as climate, land, and settlements. (Courtesy of Donald J. Huber.)

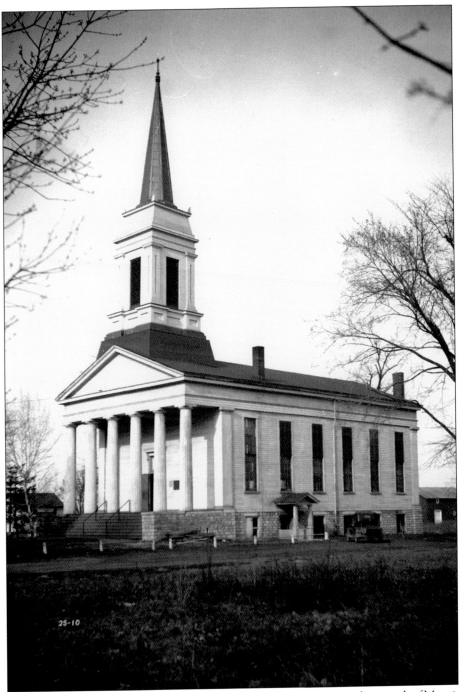

The Benjamin Godfrey Memorial Chapel was built in 1851 in response to the growth of Monticello Seminary. Services were previously held in the seminary building. Monticello Seminary and the Congregational Church combined forces to build the elegant Greek Revival church pictured here, considered to be one of the finest examples of New England–style church architecture in the United States. It is listed on the National Register of Historic Places. (Photograph by Joseph T. Golabowski, courtesy of Library of Congress.)

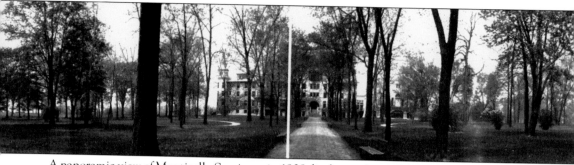

A panoramic view of Monticello Seminary in 1908 displays its beautiful campus. Capt. Benjamin Godfrey established this institution as the Monticello Female Seminary (named after Thomas Jefferson's estate Monticello) in 1838. This building was constructed in 1890 after the original building was destroyed by fire 1888. The school held a widely known reputation for its high standards of education, its fine arts and music department, and its wholesome country atmosphere. (Photograph by William H. Wiseman, courtesy of Library of Congress.)

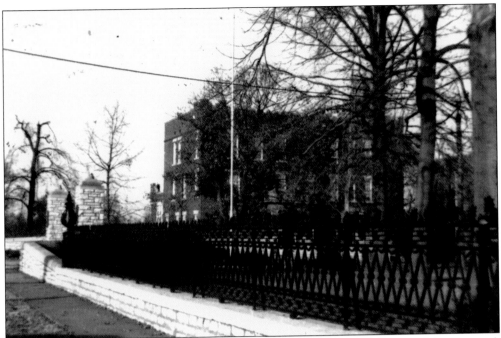

Edward Wyman, LL.D., founded the Wyman Institute in 1879 in the ornate John Bostwick mansion in Upper Alton. Wyman died unexpectedly in 1888, and Col. Albert M. Jackson, a graduate of Princeton, became principal. A few years later, ownership of the institute passed to Colonel Jackson and Maj. George D. Eaton. Students received equestrian and military training as well as exceptional academic instruction. After Colonel Jackson took over the school, it was known as the Western Military Academy. Students from all over the United States and several foreign countries attended Western Military Academy, which was recognized as some of the best military training in the country. (Above, courtesy of Madison County Historical Society; below, courtesy of Donald J. Huber.)

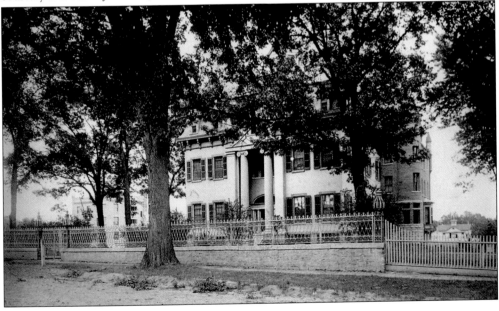

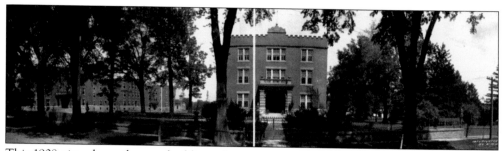

This 1908 view shows the new buildings that were constructed after fire destroyed the original Bostwick building in 1903. In less than a year, three new buildings were constructed; and soon thereafter, student enrollment had grown to 175. It closed in 1971, and the edifice is now operated as the Mississippi Valley Christian School. (Photograph by William H. Wiseman, courtesy of Library of Congress.)

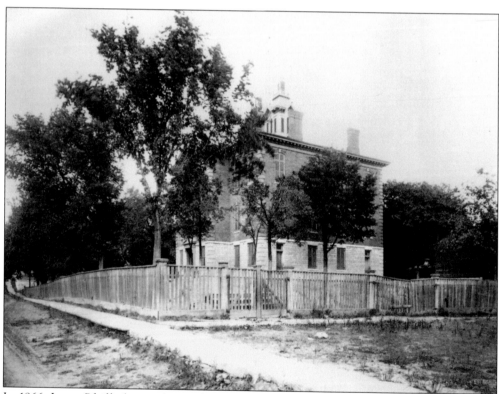

In 1866, Lucas Pfeiffenberger designed the Lincoln School, which was built on Alton Street between Tenth and Eleventh Streets. The third floor of Lincoln School was soon utilized as the high school until the first dedicated high school building was constructed in 1902 at the corner of Sixth and Langdon Streets. (Courtesy of Donald J. Huber.)

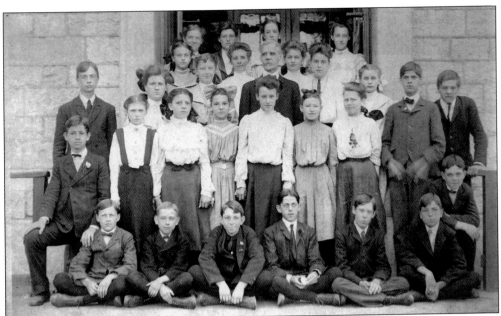

A group of students poses for a photograph in front of Lincoln School in 1905. The enrollment in Alton public schools grew from around 1,000 in 1866 to close to 4,000 in 1912. The school superintendent during that time period, Robert Haight, served continuously for 33 years in the position. (Courtesy of Donald J. Huber.)

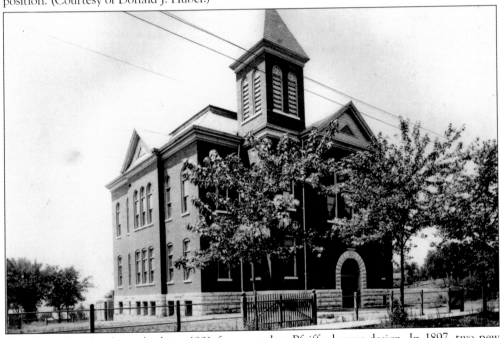

The Garfield School was built in 1891 from another Pfeiffenberger design. In 1897, two new elementary schools, named Lovejoy and Douglas, were built for African American children to attend. The Bibb family filed a suit against the school board to allow their children to attend the neighborhood school closer to their home. Eleven years later, the case was ruled in their favor. (Courtesy of Donald J. Huber.)

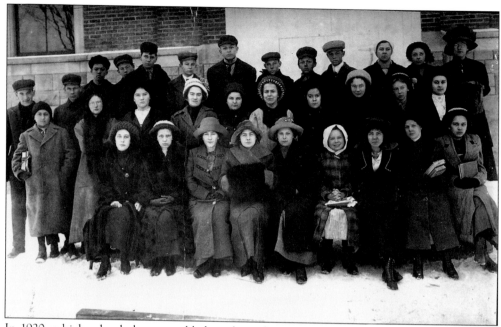

In 1920, a high school class assembled outdoors for a picture in front of Alton High School. Built in 1920 at a cost of $51,000, the building was later used as Roosevelt Junior High School after a new high school building was constructed on College Avenue in 1927. In 1865, the state legislature had granted the new Alton Board of Education the authority to establish a high school. (Courtesy of Cheryl Eichar Jett.)

Marquette High School on Danforth Street was constructed in the 1930s on the site of the old Ursuline Convent, which was built on the site of the 1856 fairgrounds. The Ursuline order has continuously provided teachers since 1859 for Alton's Catholic schools. Orchards and gardens once filled the grounds around the school. (Photograph by Cheryl Eichar Jett.)

Nine

THE CITY

From its beginnings as a ferry stop with a few humble log cabins in the area, Alton grew into a major Illinois city of industry, transportation, and education. It very nearly became the site of the state capitol. Although it did not, it did become the city to establish the first Illinois penitentiary.

During its particularly prosperous years of growth during the last half of the 1800s on into the early years of the 20th century, Alton established city services, transportation, a public school system, and paved streets. In 1912, the city claimed 55 miles of paved roads. The late 1800s and early 1900s saw fine public buildings take shape as industries and commercial enterprises flourished. The industrial success bred fortunes for a few and employment for many. Through the philanthropy of wealthy citizens, part of those fortunes supported institutions like the library and the hospitals.

By the early 1900s, several theaters and movie houses, including the Temple Theatre, the Hippodrome, and the Biograph, provided entertainment. The Alton Country Club sported a fine new clubhouse designed by Lucas Pfeiffenberger. Turner Hall on Ridge and Third Streets was the home of German social associations. There were two daily newspapers, the *Telegraph*, established in 1836, and the *Times*, and two weekly papers, the *Journal*, in German and English, and the *Banner*, a German newspaper.

Citizens could shop at their choice of 200 different commercial businesses, worship at 21 different churches, or stroll more than 100 miles of sidewalk. One might deposit money at five different banks, check books from the library, bake with flour from two mills, or have the family laundry picked up by the Stork Laundry. Alton had several physicians, including Dr. J. N. Shaff and Dr. O. O. Giberson. There were also several pharmacies, including the P. H. Paul Drug Store, Luly Drug Company (the Rexall store), E. B. Joesting, W. C. Tunker, and Charles T. Flacheneker's Red Cross Pharmacy, which advertised, "If we fill your prescriptions you live."

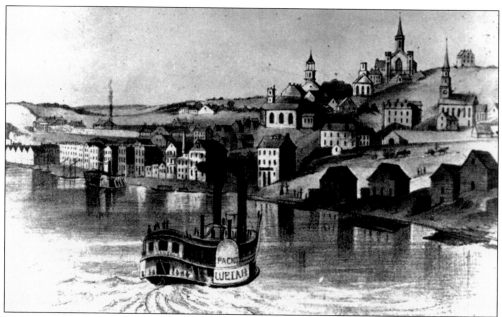

Henry Lewis, a German painter, published a book of Mississippi River scenes in the 1850s titled *Das Illustrirte Mississippi*, including this view of Alton. Lewis was obviously impressed with the city, as he observed, "The rapid development of the city of Alton from its original condition to its present prosperous state is not easily matched in enterprising Western America." (Courtesy of Madison County Historical Society.)

In 1882, the four-storied Hotel Madison was built at Broadway and Easton Streets at a cost of around $50,000. The Madison could accommodate 100 guests in its 60 rooms, feed them in fine dining rooms, and offer them outstanding views of the Mississippi River. It was known as the place where visiting notables stayed. Early in the 1900s, it was remodeled, but it was later demolished. (Courtesy of Donald J. Huber.)

The Odd Fellows Temple was erected about 1890 on Second Street. The Temple Theatre located inside the lodge was billed as the best-equipped theater in Illinois south of Chicago; it had a seating capacity of 1,200. Theater manager William M. Sauvage brought in nationally known entertainment, including George M. Cohan and Marie Dressler. Several fires in the theater sealed its fate, and it was demolished in 1976. (Courtesy of Donald J. Huber.)

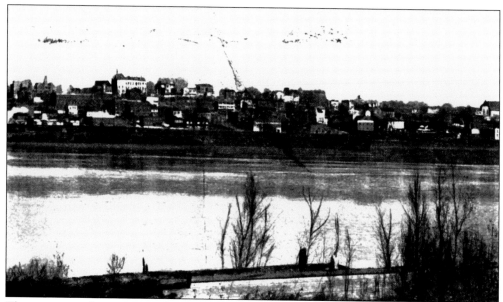

These two riverfront images of Alton date from the early 1900s. River views, bluff views, and riverfront views were popular subjects for the postcards of the time. The view above of the riverfront from Alby Street south to Langdon Street shows approximately the area of the original area that Rufus Easton platted around 1818. Naming the streets that run perpendicular to the river after his sons and daughter plus their surname, the streets are, from left to right, Alby, Easton, Alton, George, Langdon, and Henry. The original platted area extended up the hill to Ninth Street. (Courtesy of Madison County Historical Society.)

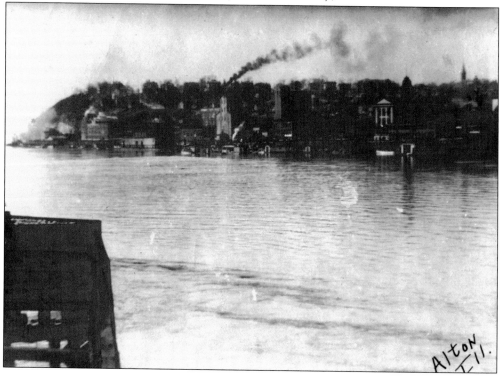

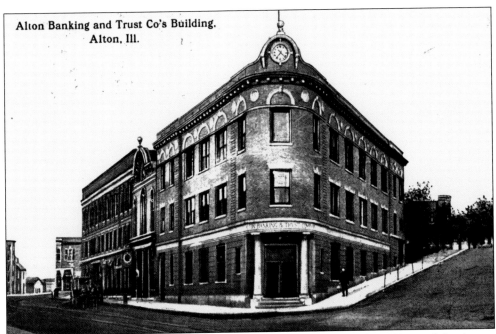

Alton Banking and Trust Co's Building,
Alton, Ill.

The Alton Banking and Trust Company was founded in 1902 by Samuel H. Wyss and the August and Herman Luer family, who had established Luer Meat Packing and later built the Mineral Springs Hotel. The Wedge Bank, as it was popularly known, opened with five employees. James Earl Ray was said to have put $1,100 in a savings account here in the 1940s while he worked for International Shoe Company's tannery in nearby Hartford. (Courtesy of Madison County Historical Society.)

The city hall was completed in 1858 in time for the seventh and final Lincoln-Douglas debate, which was held on a temporary platform constructed in front of the handsome new edifice on the Market Street side. Built at a cost of about $50,000, it was four stories high and utilized a clock in the cupola originally used in the First Baptist Church tower. (Courtesy of Madison County Historical Society.)

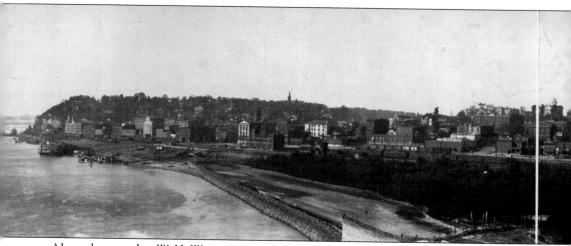

Alton photographer W. H. Wiseman pieced together this panoramic view of Alton about 1908. Shown here are sections that include major public buildings along the riverfront to the left and homes, churches, schools, and hospital up the hill. Wiseman used materials from the Louisiana

Purchase Exposition in St. Louis to build his photography studio on the corner of Broadway and George Streets. (Photograph by William H. Wiseman, courtesy of Library of Congress.)

The Illini Hotel was built in 1909 for the sum of $175,000. It could accommodate 250 guests and became popular for both conventions and local society events due to its large auditorium, complete with stage. In 1912, the Madison and the Illini were the largest of a dozen hotels in the area. The Illini later became known as the Stratford and was operated by the Gaylord family for many years. (Courtesy of Madison County Historical Society.)

This postcard view shows the public square, city hall, and the common sight of trolleys. In addition to seven steam railroads, Alton had two electric interurban lines and thorough city service. The Alton, Jacksonville and Peoria Trolley Line offered local trolley service, eventually extending to Jerseyville and Carrollton north of Alton. (Courtesy of Madison County Historical Society.)

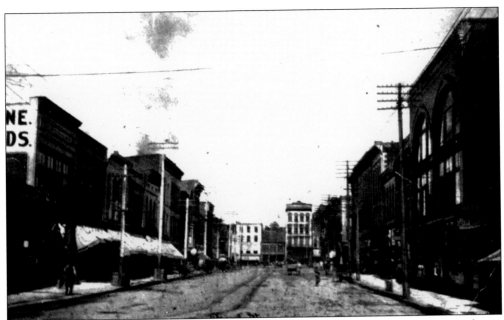

Third Street included many business establishments, including C. and G. Hartmann Hardware, Charles A. Schlueter Real Estate, W. H. Neermann Carpets and Floor Coverings, William H. Joesting Company High Grade Men's Wear, P. H. Paul Drug Store, H. M. Schweppe Company selling clothing, hats, and men's furnishings, and H. F. Lehne's Dry Goods, seen at left in this picture. (Courtesy of Madison County Historical Society.)

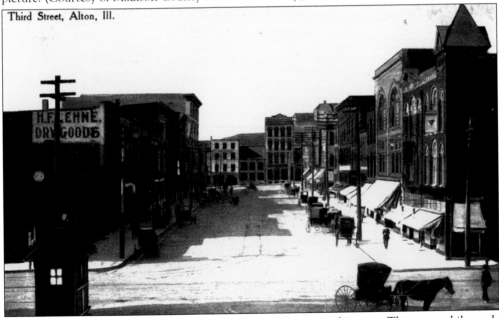

Horses and buggies lined the Third Street commercial area in this view. The automobile made its debut in Alton soon after these photographs were taken, and for some time thereafter, downtown traffic consisted of a mix of horse-drawn conveyances, automobiles, and trolleys, further congested by the steam railroad lines that crossed the downtown streets. (Courtesy of Madison County Historical Society.)

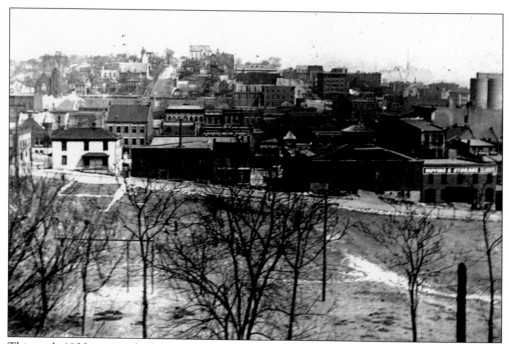

This early-1900s view of Alton shows commercial buildings including a moving and storage enterprise and grain elevators at front right. Other institutions and businesses pepper the hillside. (Courtesy of Madison County Historical Society.)

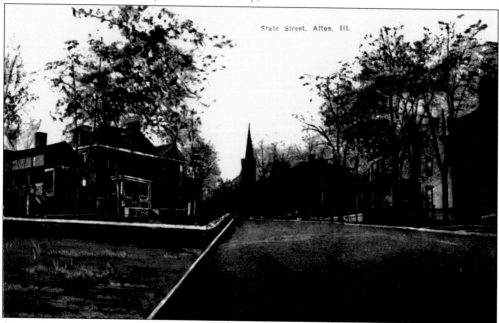

State Street ran northeast from the river up the bluff toward the neighboring community of Godfrey (first called Monticello) and the Monticello Seminary. A variety of commercial businesses such as N. S. Wittels Mercantile Company, Seely Book Store, and L. A. Meyer and Company Staple and Fancy Groceries lined the lower section of the street. Fine homes graced the upper portion. (Courtesy of Madison County Historical Society.)

In 1912, Alton and its board of trade embarked on a huge publicity campaign to attract more industry and commercial enterprise to the city. According to *Reid's Brochure of a Notable American City: Alton Illinois*, more than 60,000 pieces of publicity material were mailed out to the United States, Canada, and Mexico. This envelope from Horatio J. Bowman Real Estate enumerates "Why you should come to Alton." (Courtesy of Cheryl Eichar Jett.)

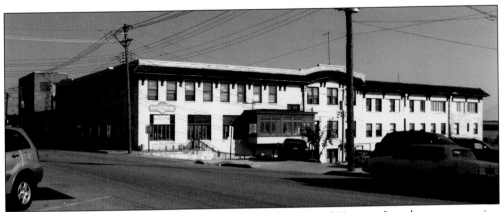

The Mineral Springs Hotel was built in 1914 after August and Herman Luer began excavation on the site to build an ice storage facility for their meatpacking plant. When a natural spring was found, the ornate Italian villa–style hotel was built instead. Business waned in the mid-1900s, and it was closed in 1971. Soon it was reopened as an antique minimall and office building. Several ghosts are said to roam about the building. (Photograph by Cheryl Eichar Jett.)

Alton was prepared to become the state capital with State House Square at Central Avenue and College Street as the designated location. The 1833 Illinois General Assembly passed a bill allowing voters to choose Alton, Jacksonville, Peoria, Springfield, Vandalia, or the state's geographic center. Alton won with over 7,500 votes. However, errors on many ballots prevented the vote from being held as binding, and thus Springfield's strong boosters won out. (Courtesy of Madison County Historical Society.)

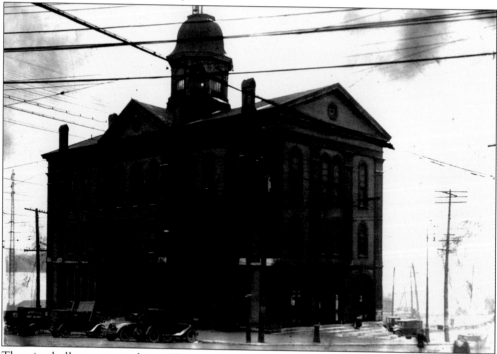

The city hall, constructed in 1858 was destroyed by fire in 1924. The building had housed, in addition to the city offices and police department, the library association, meeting rooms, market house, post office, and courts. In addition, a tavern was located in one corner of the ground floor for 20 years, causing some opposition among Alton residents. (Courtesy of Madison County Historical Society.)

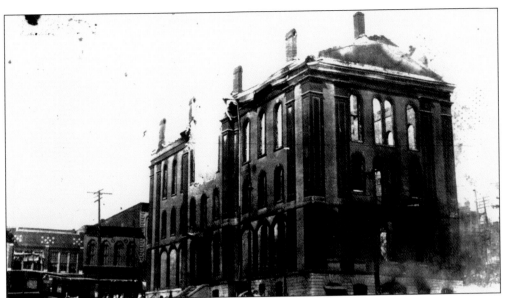

Opposition to the tavern quartered in city property plus severe overcrowding led to talk of a new city hall. However, a bond issue failed to pass. When the building burned in 1924, the solution was obvious. Arson was rumored to be the cause of the huge fire, but no case was proven. (Courtesy of Madison County Historical Society.)

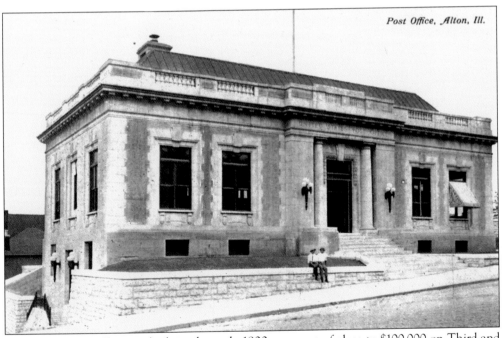

The Alton Post Office was built in the early 1900s at a cost of close to $100,000 on Third and Alby Streets. Post office business for the year 1910 totaled almost $47,000. Some 30 carriers and clerks were employed, along with a postmaster and an assistant postmaster. (Courtesy of Madison County Historical Society.)

Not long after the old city hall burned in 1924, voters in Alton approved a bond issue for the construction of a $200,000 city hall across the street from the post office. The new city hall originally was adorned with a mansard roof and stone railing similar to those on the post office, but the ornamentation was later removed. (Photograph by Cheryl Eichar Jett.)

This view of a fountain with the river beyond is a reminder that Alton is a city of fountains and charming small parks dotted throughout the city. This fountain is located at the intersection of Third and Easton Streets, by the Miller Mutual Insurance building. Another is found just a few blocks away at Court and George Streets. (Photograph by Cheryl Eichar Jett.)

Ten

THE 20TH CENTURY

The Gilded Age is considered by most historians to have concluded by the end of the 1800s, but Alton's golden age lasted well into the 20th century. As across the rest of the country, two world wars and the Great Depression took their toll on the city and its surrounding communities, although wartime always spiked industrial production. Alton, like the rest of the United States, displayed its patriotism by holding parades and war bond drives and by sending its sons off to war.

The last half of the 20th century was not kind to the Alton area, as industries found their plants becoming obsolete and the cost to retool them too great. Many closed their doors and laid off their workers. In 1983, Owens-Illinois, Inc., formerly Illinois Glass Company, closed its main shop. A new outlying shopping center adversely affected downtown Alton in the same way that new suburban shopping areas hurt downtowns everywhere.

But soon a new wave of emigrants began to arrive in Alton, weary of urban life in St. Louis or other cities. The city's charm worked its magic on these newcomers, and they saw possibilities and promises of a good life in the old buildings and small parks and hilly streets. About this time, citizens began to work for historic preservation of their architectural treasures.

Tourism has become an important part of the city's economy. The antique district, Alton Marina, Argosy Casino, Melvin Price Locks and Dam, and numerous historic sites and museums attract visitors. Alton's reputation as one of the most haunted cities in the United States brings visitors to a half-dozen haunted Alton tours.

No longer does one hear "steamship a-coming" along the riverfront. The riverfront railroad and interurban stations live on only in photographs. Some of the magnificent old buildings are gone, destroyed by fires or razed for new construction. But one can still take a river cruise or the train, albeit the Amtrak instead of the Chicago and Alton Railroad. And the beauty of the bluffs and the river still provide a scenic backdrop for picnics, family reunions, and Sunday afternoon drives.

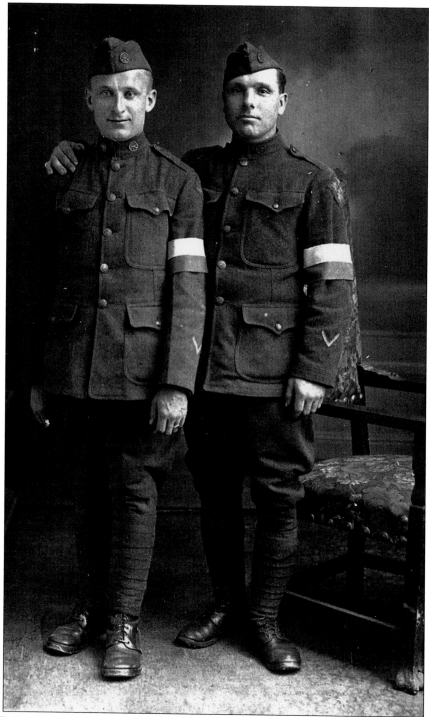

James B. Harris, a 46-year employee of the Alton Gas and Electric Light Company and a native of Alton, served in Germany during World War I. He addressed this photograph of himself (at right) and a fellow soldier to his mother, Ida Belle Harris, and another photograph to his sister Grace Harris. (Courtesy of Suzi Journey.)

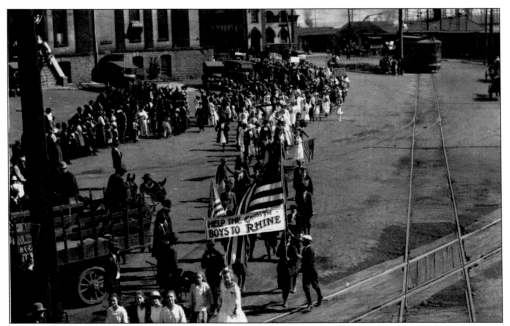

In 1918, Alton's Liberty Loan parade attracted large crowds to raise funds for the war effort. All across the United States, cities and towns held Liberty Loan parades to sell war bonds. Pres. Woodrow Wilson marched in a Liberty Loan parade that year. In San Francisco, marchers wore masks to protect themselves from the influenza epidemic that same year. (Courtesy of Madison County Historical Society.)

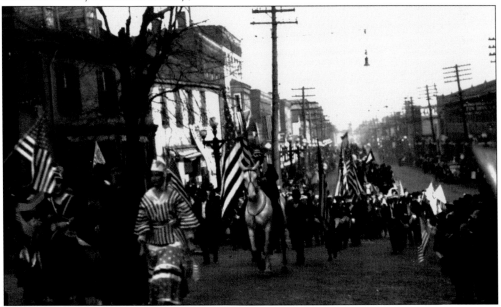

The Armistice Day Parade on November 11, 1918, celebrated the end of World War I (also called the Great War), although technically the war was not over and hostilities continued. Ironically more people were killed in 1918 by the influenza pandemic than in the war. Pres. Woodrow Wilson himself suffered from influenza while negotiating the Treaty of Versailles to end the war. (Courtesy of Madison County Historical Society.)

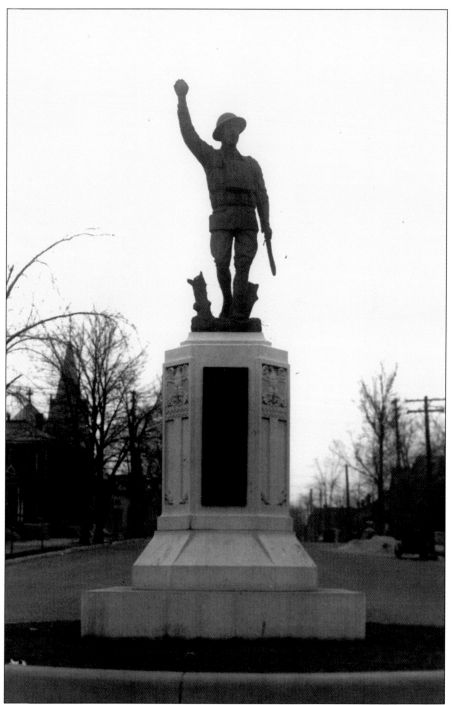

The World War I or "Dough Boy" monument was erected on November 11, 1922, at the intersection of Sixth and Henry Streets. Later it was moved to Riverside Park, where it was surrounded by floodwaters in 1943, and sometime after that moved again, this time to North Alby Street on the grounds of the Veterans of Foreign Wars. (Courtesy of Madison County Historical Society.)

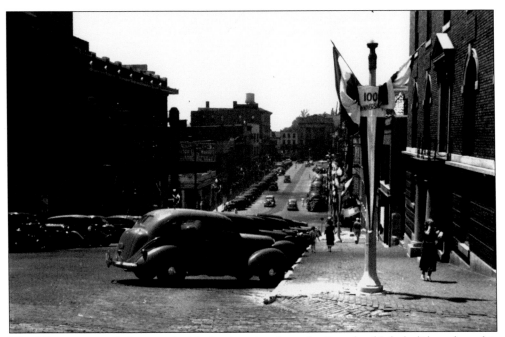

Third Street was still decorated with flag bunting from the Fourth of July holiday when this photograph was taken on July 16, 1937. The Alton area held Armistice Day, Memorial Day, and, during wartime, Liberty Loan parades. The first Memorial Day parade in Alton was in June 1868. (Courtesy of Madison County Historical Society.)

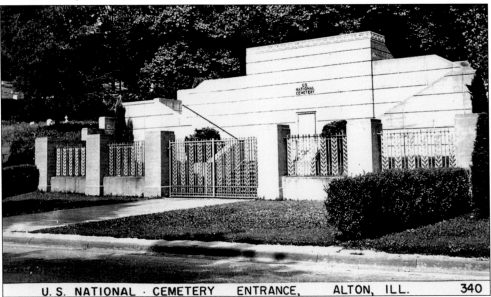

The Alton National Cemetery is a United States National Cemetery. In 1870, the half-acre lot began as a military section of the Alton City Cemetery. It was the intent to move the soldiers' remains to the United States National Cemetery in Springfield, but public protest began the process for the lot to become a United States National Cemetery. Alton donated the lot to the federal government in 1940. It is one of 139 recognized national cemeteries in the United States. (Courtesy of the Telegraph.)

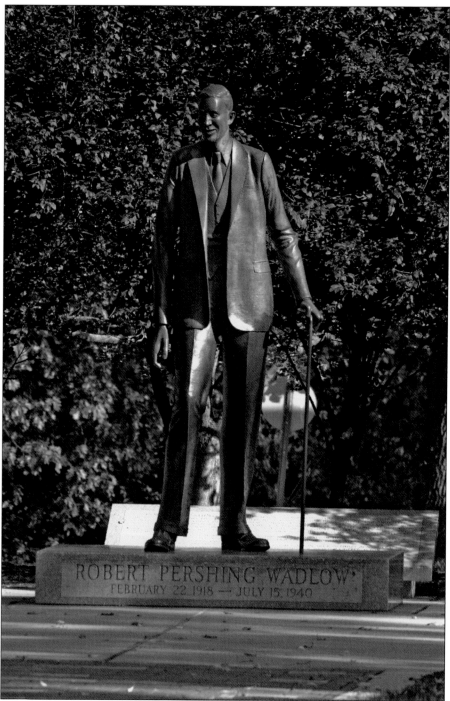

ROBERT PERSHING WADLOW
FEBRUARY 22, 1918 — JULY 15, 1940

"The Gentle Giant" Robert Wadlow was born in 1922 to average-sized parents. The friendly but shy Wadlow grew to be the tallest man in the world at the height of 8 feet, 11 inches. He toured with Ringling Brothers Circus and was a popular American celebrity. When he died at age 22, more than 40,000 people attended the funeral. This life-size bronze statue of Wadlow is located on College Avenue. (Courtesy of Alton Regional Convention and Visitors Bureau.)

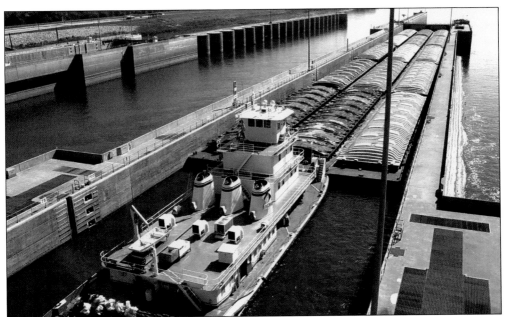

Construction of the Melvin Price Locks and Dam began in 1979 to replace the old locks and dam, which were demolished when the new system became operational. There are two lock chambers, a 600-foot lock and a 1,200-foot lock. Guided tours allow visitors to witness the river navigation control process and view the river at a height of eight stories high from atop the locks and dam. (Courtesy of Alton Regional Convention and Visitors Bureau.)

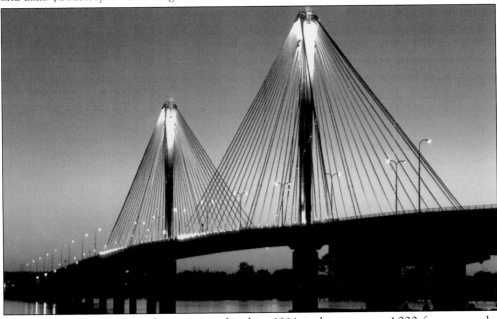

The elegant new Clark Bridge was completed in 1994 and spans over 4,000 feet across the Mississippi River. The cable-stay-design bridge cost $118 million and required 44,100 cubic yards of concrete, 8,100 tons of steel, and close to 200 miles of cable to construct. At the center of the channel, the river averages 40 feet deep. (Photograph by Gene Kunz, courtesy of Alton Regional Convention and Visitors Bureau.)

Alton's antique district offers several dozen antique and specialty stores to browse in. Most are housed in historic buildings, including the Mineral Springs Hotel and the former Kendall Cracker Factory building. Along "Antique Row" are also numerous restaurants. (Photograph by Gene Kunz, courtesy of Alton Regional Convention and Visitors Bureau.)

Eric Robinson's Underground Railroad tours are offered for an appreciation of how Alton became a safe haven for escaping slaves. Alton was a significant stop along the Underground Railroad for slaves attempting to throw off the bonds of slavery. Robinson is a local historian and researcher whose special interest is the Underground Railroad. (Courtesy of Alton Regional Convention and Visitors Bureau.)

The Alton Marina is just north of the Clark Bridge and is tucked into a protected cove. The marina is home to parasailers, fishermen, and boating enthusiasts. The marina offers floating docks and structures, a convenience store, fueling, boats for sale, and land storage. The antique district and historic downtown Alton are just a few blocks away. (Courtesy of Alton Regional Convention and Visitors Bureau.)

Every year, hundreds of American bald eagles migrate south along the Mississippi Flyway to nest in the bluffs. From December through February, visitors come to the Alton area for eagle watching. Popular places to spot the magnificent birds are the Pere Marquette State Park, the Riverlands Migratory Bird Sanctuary, and the Two Rivers Wildlife Refuge. Other species, such as the trumpeter swan and the American white pelican, are also seen. (Photograph by Gene Kunz, courtesy of Alton Regional Convention and Visitors Bureau.)

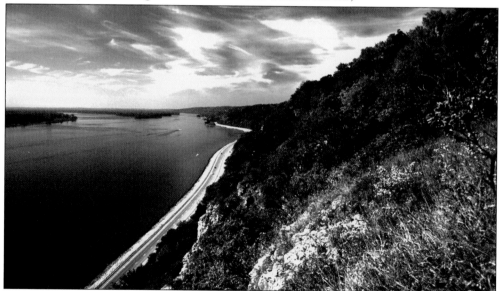

The Great River Road allows visitors to experience the timeless beauty of the Mississippi River along the bluffs for miles north of Alton. One can watch the river or admire the woods and cliffs as did previous generations of visitors by steamboat or by train. In Alton, the river still beckons. (Photograph by Keith Wedoe, courtesy of Alton Regional Convention and Visitors Bureau.)

BIBLIOGRAPHY

All around Alton: 2008 Visitor Guide. Alton, IL: Alton Regional Convention and Visitors Bureau, 2007.

Beard, William D. "'I have labored hard to find the law': Abraham Lincoln and the Alton and Sangamon Railroad." *Illinois Historical Journal* 85, no. 4 (Winter 1992): 209–220.

Beecher, Edward. *Narrative of the Riots at Alton: In Connection with the Death of Rev. Elijah P. Lovejoy.* Alton, IL: George Holton, 1838. Northern Illinois University Libraries Digitization Projects, lincoln.lib.niu.edu/file.php?file=beecher.html.

Buckmaster, Julia A., George H. Mosser, and James Allan Reid. *Alton Illinois: Reid's Brochure of a Notable American City.* St. Louis and Alton: James Allan Reid, Book Maker, 1912.

Davis, James E. *Frontier Illinois.* Bloomington and Indianapolis: Indiana University Press, 1998.

Dunphy, John J. *It Happened at the River Bend.* Alton, IL: Second Reading Publications, 2007.

Gill, Charlene. *Bridging the Millennium: Highlighting the Alton Area and Its Mayors.* Alton, IL: Alton Area Historical Society and Emons Printing Company, 1999.

Hair, James T. *Gazetteer of Madison County.* New York: Compiler, 1866.

Kruty, Paul. "A New Look at the Beginnings of the Illinois Architects Licensing Law." *Illinois Historical Journal* 90, no. 3 (Autumn 1997): 154–172.

Mueller, Owen W. "'His countenance glowed with animation': Lincoln takes the moral high ground at the fifth Lincoln-Douglas debate." *Illinois Heritage* 11, no. 1 (January-February 2008): 12–16.

Norton, W. T., ed. *Centennial History of Madison County, Illinois and Its People 1812 to 1912.* Chicago and New York: Lewis Publishing Company, 1912.

Portrait and Biographical Record of Madison County, Illinois. Chicago, IL: Biographical Publishing Company, 1891.

Stetson, Charlotte. *Alton: A Pictorial History.* St. Louis, MO: G. Bradley Publishing, Inc., 1986.

Discover Thousands of Local History Books
Featuring Millions of Vintage Images

Arcadia Publishing, the leading local history publisher in the United States, is committed to making history accessible and meaningful through publishing books that celebrate and preserve the heritage of America's people and places.

Find more books like this at
www.arcadiapublishing.com

Search for your hometown history, your old stomping grounds, and even your favorite sports team.

Consistent with our mission to preserve history on a local level, this book was printed in South Carolina on American-made paper and manufactured entirely in the United States. Products carrying the accredited Forest Stewardship Council (FSC) label are printed on 100 percent FSC-certified paper.

MADE IN THE